The Life
of
Raphael

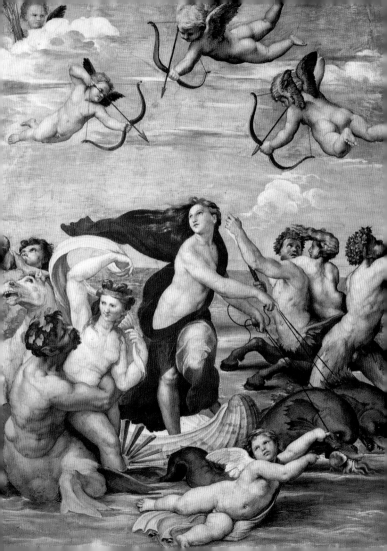

The Life of
Raphael

Giorgio Vasari

Introduction by Jill Burke

The J. Paul Getty Museum, Los Angeles

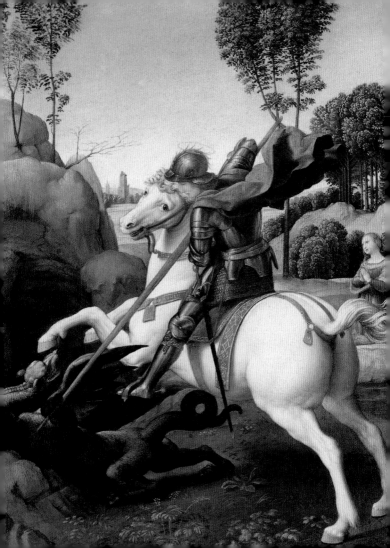

CONTENTS

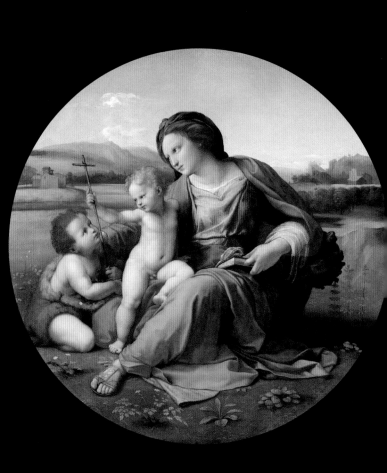

INTRODUCTION

JILL BURKE

On 6th April 1520, the city of Rome was in mourning. So shocked was the papal court by the sudden death of a young man of incredible achievement and promise, there was no talk of anything else. The Pope himself, it was said, openly wept when he heard the news. A grand funeral cortège of 100 torchbearers was organised to bury the dead man in the Pantheon, a sacred space formerly reserved to canons of the church. Raphael – painter, architect, surveyor of antiquities, and sparkling socialite – had died, on Good Friday, his 37th birthday.

The reaction of the Roman court gives us some idea of the impact that Raphael had on his contemporaries. In an age when painters were only just starting to be considered artists – people who worked with their imaginations, as opposed to craftsmen, who worked with their hands – Raphael was a trail-blazer. He rubbed shoulders with the very highest in society, counting popes, cardinals, dukes, and the literati amongst his friends; he was

Opposite: The Alba Madona, c. 1510

7

universally known for his gentility towards all who approached him; his knowledge of the classical world was prodigious, at just the time that such talents were fully appreciated; and, of course, he was a brilliantly talented painter.

Giorgio Vasari's *Life of Raphael* is an account of one of the Renaissance's greatest artists by its greatest art historian. The *Life* remains a major source for our understanding of the artist's career, but gives us much more than valuable information. Vasari's enthusiasm for his subject allows us to recapture some of that sense of awe and wonder that must have struck contemporaries when they saw the works of Raphael for the first time. This is especially valuable because Raphael has been so influential on the development of Western art, and so much reproduced, that it can be difficult to appreciate his works with fresh eyes.

Vasari's biography of Raphael was only one of a series of artists' lives that he published together in two editions, the first in 1550 and the second, much expanded, in 1568. His purpose was to trace developments in Italian art over the previous 350 or so years, the period we now call the Renaissance. He started his story with

Opposite: Drawing for the Alba Madona, c. 1510

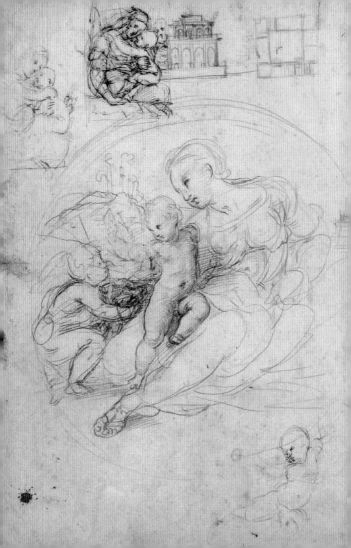

the first people who, he believed, revived the dormant arts of painting, sculpture, and architecture – Cimabue and Giotto – and he ended with the 'perfection' of his own day. Vasari divided his biographies into three parts, roughly coinciding with the fourteenth, fifteenth and sixteenth centuries. Each of these three ages, according to Vasari, improved on the former. The third age, in which the *Life* of Raphael belongs, started with the work of Leonardo da Vinci (1452-1519) – who, according to Vasari, revolutionised the 'stilted' art of the second age. The biographies culminate in the *Life* of Michelangelo (1475-1564), who for Vasari represented the pinnacle of all three arts of painting, sculpture and architecture.

The life of Raphael occupies a particular position in Vasari's plan. It is a near contemporary account by an enthusiastic consumer of Raphael's life and works, someone who did not only want to paint like Raphael, but also wanted to be Raphael. He might never have 'excelled that wonderful groundwork of ideas, and that groundwork of art' that Vasari sees in Leonardo; he might never have reached the peak of Michelangelo's 'terribilità' in his perfected painting and architecture; yet neither did Raphael suffer from the social eccentricities that dogged the careers of these two men. As Vasari put it, 'Nature created Michelangelo to excel and conquer in art, but Raphael to excel in art and in manners also'.

Raphael managed to be a great painter and a great dinner guest. This was of no small importance in the life of the burgeoning Renaissance courts, where a good social bearing could be almost as important to career advancement as artistic talent.

Vasari holds Raphael up as a model for young artists to follow. As well as stressing his genteel social bearing, and his ability to hold his own in all social ranks, Vasari constantly emphasises Raphael's ability to absorb the lessons of great masters, and through this to create his own style. His was not a genius, according to Vasari, that emerged fully formed, untouchable and unchangeable. It was a talent brought about by hard work and study. Others should learn from his example, so that they 'may rise superior to disadvantages as Raphael did by his prudence and skill'. Vasari had already profited from his own advice. Elsewhere in the *Lives* he recounts how as a young painter in Rome in the early 1530's, he and his friend Francesco Salviati rushed to the Vatican to draw after Raphael's frescos whenever the Pope was absent, staying 'from morning until night, eating nothing but a bit of bread and almost freezing to death'.

Vasari's assessment of Raphael as a brilliant appropriator of the best of other people's styles is borne out in a brief examination of the painter's artistic career. Raphael was born in Urbino in 1483, the son of a court painter,

Giovanni Santi. By around 1500 he was associated – Vasari say apprenticed, though this is not certain – with the Umbrian painter, Pietro Perugino (*c.* 1450-1523), then at the height of fashion. Vasari notes that in some paintings 'he imitated [Perugino] so exactly in everything' that it is hard to tell their works apart. To take an example, the earliest extant altarpiece by Raphael, the *Mond Crucifixion* (1503, National Gallery), does indeed owe a great debt to Perugino. This is immediately apparent in the stable geometry of the composition, which lends a feeling of calm permanence to the image; the idealised oval faces of his figures, their almond eyes, small mouths and whimsically tilted heads; and the landscape background, with its slender trees emerging from rolling hills.

In 1504, Raphael went to Florence. According to Vasari, Raphael's contact with the Florentine milieu brought about 'an extraordinary improvement in his art and style', and it is true that his paintings visibly change under the influence of the more muscular, physically charged and psychologically tense work of the Florentine masters. A good example of this is his altarpiece of the *Entombment*, commissioned in 1505-7 for the Baglioni chapel in San

Opposite: The Mond Crucifixion, 1503

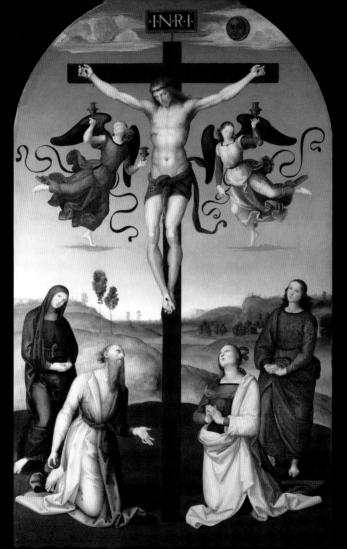

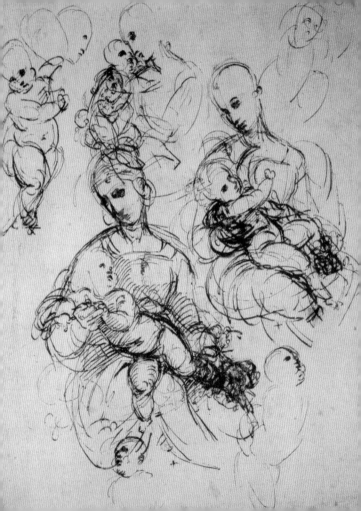

Francesco al Prato in Perugia (now Borghese Gallery; ill. p. 43). Through the surviving preparatory drawings, we can witness Raphael's absorption of Florentine visual idiom. The earliest compositional sketch (Ashmolean Museum) suggests that the young Umbrian first conceived of the painting as similar to that of Perugino's *Deposition* of 1495 – an essentially static group of standing and sitting mourners surrounding Christ's supine body. By the time of the finished painting, however, we have a complete re-articulation of the story. Here the two men of the central group seem to heave Christ's body from an unseen cross, while Mary Magdalen's hair flies behind her as she moves to support Christ's hand and reaches out to touch his head. Just behind them to the right, the Virgin Mary, swooning in grief, is caught by three women. From an originally static compositional idea, therefore, emerges a final painting where everyone is in movement. Raphael had clearly been looking at Leonardo's Virgin and Child with St Anne groups, which are masterly expositions of action suspended in time. Judging by the straining muscles in the bare arm of the young man carrying Christ, he had also learned from Michelangelo's painstaking depiction of nude male anatomy. The

Opposite: Sheet of drawings, c. 1506-07

twisting pose of the seated woman in the Virgin Mary group is also a reworking of the pose of the Virgin on Michelangelo's *Doni Tondo* (Uffizi).

Draughtsmanship was key to Raphael's learning process. One can witness this in a sheet of rapidly sketched Virgin and Child studies (British Museum, ill. p. 14), where he creatively engages with Michelangelo and Leonardo to rework the familiar image of the Virgin and Child, here experimenting with the startling diagonal movement of the Christ Child in Michelangelo's *Taddei Tondo* (Royal Academy, London).

Raphael was able to see many of Michelangelo's and Leonardo's works because they were all patronised by a tight-knit group of élite Florentine patrons, for whom he produced several portraits (such as those of Agnolo Doni and his wife, Uffizi) and domestic religious images (such as the *Madonna del Cardellino*, Uffizi, ill. p. 36). Despite his successes in Florence, he only had one commission for an altarpiece for the city. This was the *Madonna del Baldacchino*, (Pitti Palace). It was destined for the church of Santo Spirito, but left unfinished when Raphael was enticed to Rome on the promise of richer artistic pickings in 1508.

It is in the Rome of Pope Julius II (ruled 1503-13) and Leo X (ruled 1513-1523) that Raphael secured his place in posterity in just over a decade of extraordinary

artistic creativity. During this time, with the help of a large and successful workshop, he was responsible for decorating several rooms in the Vatican. He started, in 1508-12, with the Stanza della Segnatura, originally almost certainly a papal library, with frescos that include his celebrated *Disputà* (ill. pp. 56-57) and the *School of Athens* (ill. pp. 46-47). He went on to design two more rooms in the papal apartments – now called the Stanza d'Eliodoro (1512-14, ill. pp. 66-67, 70-71) and the Stanza dell'Incendio (1514-17, ill. pp. 90-91) – and supplied some of the designs for an audience chamber, now called the Sala di Constantino, that was mainly executed by his workshop after his death. The paintings in the Vatican Stanze show a great deal of experimentation with the use of motifs from the classical artefacts Raphael was enthusiastically studying at this time, a playing with effects of light and colour – especially noticeable in the nighttime scene of the *Liberation of St Peter* (ill. pp. 66-67) in the Stanza d'Eliodoro – and an astonishing gift for inventive composition. His talent for design was also called upon by Leo X in 1515 in the project for tapestries for the Sistine Chapel. Raphael designed ten cartoons of the Acts of the Apostles, eight of which can now be

Overleaf: The Charge to Peter, tapestry cartoon, 1515-16

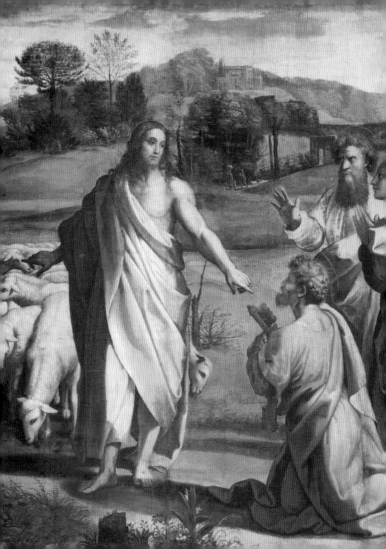

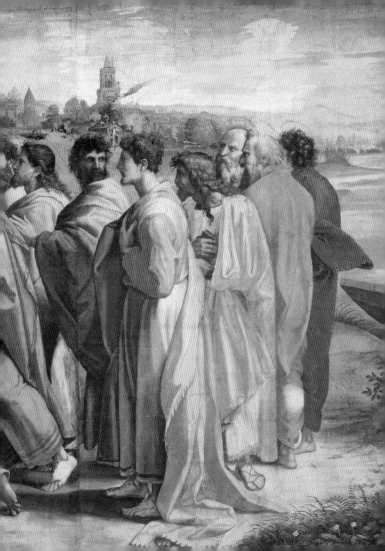

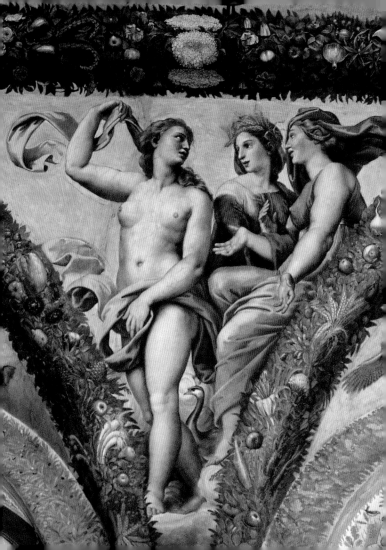

seen in the V&A Museum (ill. pp.18-19 and 104-105). The tapestries themselves, made in Brussels, remain in the Vatican.

Raphael's main secular patron in Rome was the wealthy Sienese merchant Agostino Chigi. He designed and partially executed two chapels for him – his funerary chapel in Santa Maria del Popolo, and another in Santa Maria della Pace. Chigi had also created a suburban villa (now called the Villa Farnesina), and, with the help of Raphael and other artists transformed it into a palace of pleasure. Chigi's dinner parties were legendary for their decadence – at one all his diners were famously told to toss their gold plates into the Tiber after finishing each course – and they were held against the backdrop of frescos by the best artists working in Rome. Raphael painted his *Triumph of Galatea* (frontispiece) in the loggia in 1512 and his workshop decorated the entrance loggia to the villa with suitably sensuous scenes from the story of Cupid and Psyche in 1518 (ill. opposite and pp.100-101).

It is in his account of Raphael's work with Chigi that Vasari introduces his only real criticism of Raphael – the artist's love of what Vasari delicately terms 'secret pleasures', which he notes disapprovingly were indulged by

Opposite: Detail from Loggia di Psiche, Venus, Ceres and Juno, 1517-18

his patron: when Raphael was constantly distracted from his work in Chigi's villa by his love for his mistress, the merchant just asked her to move in to keep Raphael working. It has to be said that Raphael's amatory excesses were fairly typical for members of the Roman court in the early 1500's. In a town where being married was a positive bar to career advancement – many of the best jobs in the curia were only open to clerics who had to be single – keeping concubines and engaging in a flourishing courtesan culture was expected behaviour.

Raphael's amatory adventures certainly did not adversely affect his standing in Rome. Along with his workshop, he executed several altarpieces for members of the papal court. These include the *Madonna di Foligno* (1512, Vatican Museums, ill. p. 62), with its extraordinary depiction of light over clouds, the fresco of the *Prophet Isaiah*, for the chapel of Johann Goritz in S. Agostino (1512, ill. opposite) and the *Transfiguration* (ill. p. 106), commissioned by Cardinal Giulio de' Medici in early 1517. Raphael's relationship with Michelangelo is key to understanding these last two works. Michelangelo had too been enticed to Rome from Florence by the promise of papal patronage, and between 1508 and

Opposite: The Prophet Isaiah, 1511-12

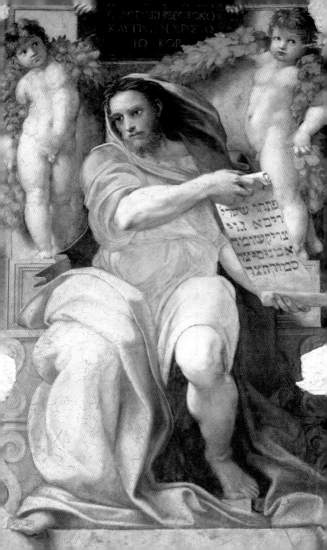

1512 had painting the Sistine Chapel ceiling. Seemingly to Michelangelo's chagrin, Raphael managed to see the ceiling before it was finished, and it had a great effect on his subsequent paintings. Nowhere is this clearer than the *Prophet Isaiah*, which still can be seen in the church of S. Agostino, and which is transparently a homage to the prophets in the Sistine in its basic composition (a seated prophet surrounded by two boys), the sweeping grandeur of the prophet's gesture, and even the acidic hues of the drapery.

The *Transfiguration*, on the other hand, was commissioned with the explicit intention of pitting the two masters against each other. It was originally intended to be shipped to the cathedral of Narbonne, Cardinal Giulio's see, alongside a painting of the *Raising of Lazarus* painted by Sebastiano del Piombo using designs by Michelangelo (National Gallery). Raphael took the competition very seriously indeed, executing the painting entirely with his own hands. His painstaking preparation is revealed in several existing drawings, including some beautiful studies for heads of apostles (ill. opposite and p. 115). Raphael was struck down by a fever – the result, Vasari says of 'an unusually wild debauch' – and the *Transfiguration* was to be the last work he completed. It was displayed, together with the *Lazarus*, in the Vatican on Raphael's death. Both were much praised, but it was Raphael's painting

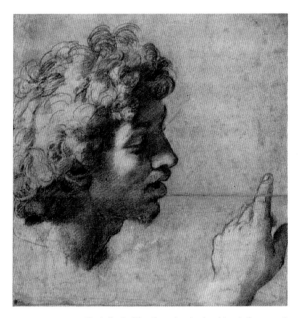

Study for the Transfiguration: head and hand of an apostle

that was kept for the Romans to enjoy. The *Lazarus* was duly sent to France, but the *Transfiguration* was placed on the high altar of the church of San Pietro in Montorio, suggesting that the painter's soul would rise to heaven and his fame would last for posterity.

Vasari, Raphael's most passionate biographer, also acted to preserve for posterity the memory of a man who, he believed, had perfected the arts of painting and living alike, in the hope that it would inspire future generations of artists to follow his example. As he insists at the end of the *Life*, 'those who imitate [Raphael's] labours in art will be rewarded by the world, as those who copy his virtuous life will be rewarded in heaven.'

VITA DI RAFFAELLO DA VRB.
PIT. ARCHITETTO.

The Life of Raphael Sanzio of Urbino,
painter and architect

GIORGIO VASARI

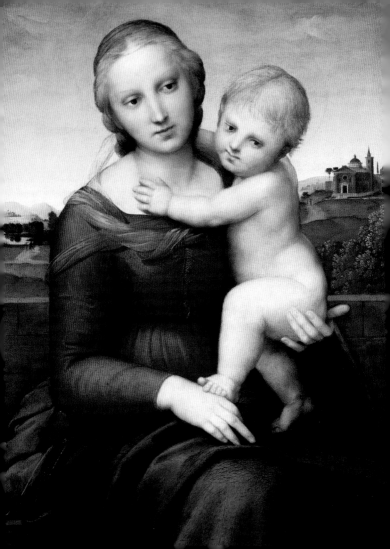

The liberality with which Heaven now and again unites in one person the inexhaustible riches of its treasures and all those graces and rare gifts which are usually shared among many over a long period is seen in Raphael Sanzio of Urbino, who was as excellent as gracious, and endowed with a natural modesty and goodness sometimes seen in those who possess to an unusual degree a humane and gentle nature adorned with affability and good-fellowship, and he always showed himself sweet and pleasant with persons of every degree and in all circumstances. Thus Nature created Michelangelo Buonarroti to excel and conquer in art, but Raphael to excel in art and in manners also. Most artists have hitherto displayed something of folly and savagery, which, in addition to rendering them eccentric and fantastical, has also displayed itself in the darkness of vice and not in the splendour of those virtues which render men immortal. In Raphael, on the other hand, the rarest gifts were combined with such grace, diligence, beauty, modesty and good character that they would have sufficed to cover the ugliest vice and the worst blemishes. We may indeed say that those who possess such gifts as Raphael are not mere

Opposite: Madonna and Child (the Small Cowper Madonna), c. 1505

men, but rather mortal gods, and that those who by their works leave an honoured name among us on the roll of fame may hope to receive a fitting reward in heaven for their labours and their merits.

Raphael was born at Urbino, a most important city of Italy, in 1483, on Good Friday, at three in the morning, of Giovanni de' Santi, a painter of no great merit, but of good intelligence and well able to show his son the right way, a favour which bad fortune had not granted to himself in his youth. Giovanni, knowing how important it was for the child, whom he called Raphael as a good augury, being his only son, to have his mother's milk and not that of a nurse, wished her to suckle it, so that the child might see the ways of his equals in his tender years rather than the rough manners of clowns and people of low condition. When the boy was grown, Giovanni began to teach him painting, finding him much inclined to that art and of great intelligence. Thus Raphael, before many years and while still a child, greatly assisted his father in the numerous works which he did in the state of Urbino. At last this good and loving father perceived that his son could learn little more from him, and determined to put him with Pietro Perugino, who, as I have already said, occupied the first place among the painters of the time. Accordingly Giovanni went to

Perugia, and not finding Pietro there he waited for him, occupying the time in doing some things in S. Francesco. When Pietro returned from Rome,[1] Giovanni being courteous and well bred, made his acquaintance, and at a fitting opportunity told him what he wished in the most tactful manner. Pietro, who was also courteous and a friend of young men of promise, agreed to take Raphael. Accordingly Giovanni returned joyfully to Urbino, and took the boy with him to Perugia, his mother, who loved him tenderly, weeping bitterly at the separation.[2] When Pietro had seen Raphael's method of drawing and his fine manners and behaviour, he formed an opinion of him that was amply justified by time. It is well known that while Raphael was studying Pietro's style he imitated him so exactly in everything that his portraits cannot be distinguished from those of his master, nor indeed can other things, as we see in some figures done in oils on a panel in S. Francesco at Perugia for Madonna Maddalena degli Oddi.[3] It represents an Assumption, Jesus Christ crowning the Virgin in heaven, while the

(1) Perugino was in Perugia in 1490 and again in 1499.
(2) Raphael's mother died in 1491 when he was only eight years old. His father remarried, and died in 1494.
(3) Painted 1502; now in the Vatican Museums.

twelve Apostles about the tomb are contemplating the celestial glory. The predella contains three scenes: the Annunciation, the Magi adoring Christ, and the Presentation in the Temple. This work is most carefully finished, and anyone not skilled in style would take it to be by the hand of Pietro, though there is no doubt that it is by Raphael. After this Pietro returned on some business to Florence, and Raphael left Perugia, going with some friends to Città di Castello. Here he did a panel in S. Agostino in that style, and a Crucifixion in S. Domenico, which, if not signed with Raphael's name, would be taken by everyone to be a work of Perugino. [1] In S. Francesco in the same city he also did a Marriage of the Virgin; which shows that Raphael was progressing in skill, refining upon the style of Pietro and surpassing it. [2] This work contains a temple drawn in perspective, so charmingly that it is a wonder to see how he confronted the difficulties of this task. Raphael had thus acquired a great reputation in this style when the library of the Duomo at Siena was allotted by Pope Pius II to

(1) Painted 1503; now in the National Gallery and known as the Mond Crucifixion. See illustration p. 13 (2) The *Sposalizio* of the Brera, Milan, painted in 1504, illustrated opposite.

Opposite: The Marriage of the Virgin (the Sposalizio), 1504

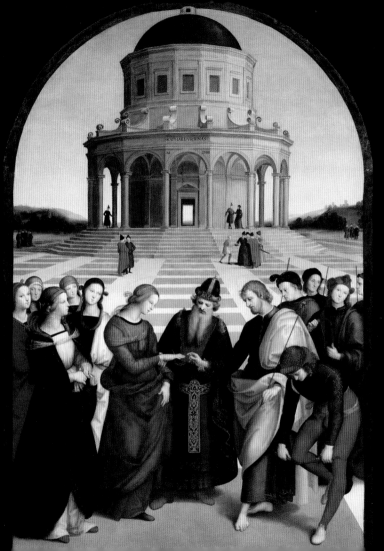

Pinturicchio.[1] As he was a friend of Raphael, and knew him to be an admirable draughtsman, he brought him to Siena, where Raphael drew some of the cartoons for that work. He did not finish it because his love for art drew him to Florence,[2] for he heard great things from some painters of Siena of a cartoon done by Leonardo da Vinci in the Pope's Hall at Florence of a fine group of horses, to be put in the hall of the palace, and also of some nudes of even greater excellence done by Michelangelo in competition with Leonardo. This excited so strong a desire in Raphael that he put aside his work and all thought of his personal advantage, for excellence in art always attracted him.

Arrived in Florence, he was no less delighted with the city than with the works of art there, which he thought divine, and he determined to live there for some time. Having struck up a friendship with Ridolfo Ghirlandaio, Aristotele S. Gallo, and other young painters, he was well received, especially by Taddeo Taddei, who was always inviting him to his house and table, being one who loved the society of men of ability. Raphael, who was courtesy itself, in order not to

(1) In 1502, but by the nephew of Pius II, Francesco Piccolomini, who afterwards became Pope as Pius III. (2) In 1504.

be surpassed in kindness, did two pictures for him in a transitional style between the early manner of Pietro and of the other which he learned afterwards, and which was much better, as I shall relate. These pictures are still in the house of the heirs of Taddeo. [1] Raphael was also very friendly with Lorenzo Nasi, and as Lorenzo had newly taken a wife, he painted him a picture of a babe between the knees of the Virgin, to whom a little St. John is offering a bird, to the delight of both. Their attitude displays childish simplicity and affection, while the picture is well coloured and carefully finished, so that they appear to be actual living flesh. [2] The Madonna possesses an air full of grace and divinity, the plain, the landscape and all the rest of the work being of great beauty. This picture was greatly valued by Lorenzo Nasi in memory of his close friend and for its excellent workmanship. But it was severely damaged on 17 November 1548, when the house of Lorenzo was crushed, together with the beautiful houses of the heirs of Marco del Nero and many others, by a landslip from Monte S. Giorgio.

(1) The Madonna del Prato, now in the Kunsthistorisches Museum, Vienna, is one, the other possibly the Bridgwater Madonna, now in the National Gallery of Scotland, Edinburgh. (2) Now in the Uffizi, known as the Madonna del Cardellino, illustrated overleaf

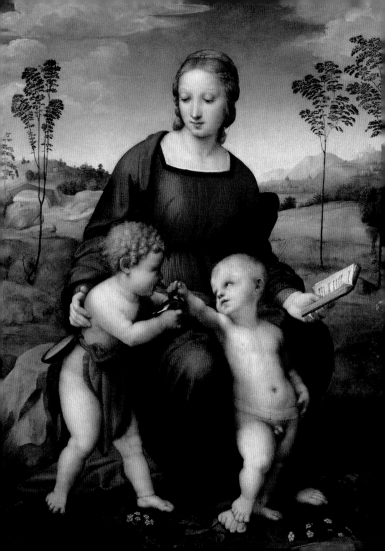

However, the pieces were found among the debris, and were carefully put together by Battista, Lorenzo's son, who was very fond of the arts. After these works Raphael was forced to leave Florence and go to Urbino, because, owing to the death of his father and mother, all his things were in disorder. While staying there he did two small but very beautiful Madonnas in his second manner for Guidobaldo da Montefeltro, then captain of the Florentines.[1] These are now the property of the illustrious Guidobaldo, Duke of Urbino.[2] For the same captain he did a small picture of Christ praying in the Garden, the three Apostles sleeping in the distance. This painting is as delicately finished as a miniature. After remaining for a long time in the possession of Francesco Maria, Duke of Urbino, it was given by his illustrious consort, Leonora, to Don Paolo Giustiniano and Don Pietro Quirini, Venetians, hermits of the Camaldoli. They placed it in a principal chamber of the hermitage, as a thing of rare virtue, a work of Raphael, and the gift of so great a lady, and there it is held in the esteem which it merits.[3]

After settling his affairs, Raphael returned to

(1) Captain from 1495 to 1498. (2) Lost. (3) Lost.

Opposite: Madonna del Cardellino, 1506

Perugia, where he painted for the Ansidei Chapel, in the church of the Servites, a picture of Our Lady, St. John the Baptist and St. Nicholas.[1] In the Lady Chapel of S. Severo, in the same city, a small Camaldolite monastery, he painted in fresco a Christ in Glory, God the Father surrounded by angels, with six saints seated, three on either side, St. Benedict, St. Romuald, St. Laurence, St. Jerome, St. Maur and St. Placidus.[2] To this fine fresco he put his name in large letters, easily seen. The nuns of S. Antonio da Padova, in the same city, employed him to paint a Madonna with a clothed Christ, as they desired, with St. Peter, St. Paul, St. Cecilia and St. Catherine, the heads of the two holy virgins being the sweetest and purest imaginable, with their varied attire, a rare thing in those days. Above this he painted a fine God the Father in a lunette, and three scenes of small figures in the predella of Christ praying in the Garden, bearing the cross, the soldiers driving Him being very vigorous, and dead in the lap of His Mother.[3] This is a marvellous work, greatly

(1) Painted 1506; now National Gallery, London. (2) In 1505. Still in situ (3) Metropolitan Museum of Art, New York, together with the predella Agony; Christ Bearing the Cross is in the National Gallery, London, and the Lamentation is in the Isabella Stewart Gardner Museum, Boston.

Opposite: Madonna and Child Enthroned with Saints, c.1504

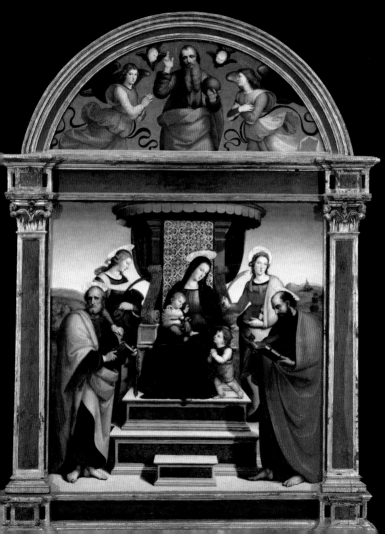

valued by the nuns and much admired by all artists. It is well known that after his stay in Florence Raphael greatly altered and improved his style, through having seen the works of the foremost masters; and he never reverted to his former manner, which looks like the work of a different and inferior hand.

Before Raphael left Perugia, Madonna Atalanta Baglioni begged him to do a panel for her chapel in the church of S. Francesco. But not being able to do so then, he promised that he would not fail her when he returned from Florence, where he had affairs. At Florence he devoted infinite pains to the study of his art, and did the cartoon for this chapel, intending to carry it out as soon as he had the opportunity, as he did. Agnolo Doni was then in Florence, and though sparing in other things, spent willingly upon paintings and sculpture, of which he was very fond, though he saved as much as he could. He had portraits of himself and his wife done, which may be seen in the house of his son Gio. Battista, built by Agnolo, a fine structure and most convenient in the Corso de' Tintori, near the corner of the Alberti in Florence.[1] For Domenico Canigiani Raphael did a Madonna with the Child Jesus playing with a St. John held to him

(1) Pitti Palace, Florence.

by St. Elizabeth, who is regarding St. Joseph, leaning with both hands on a staff and bending his head towards Elizabeth, as if marvelling and praising the greatness of God that so old a woman should have a little child.[1] All of them seem to be marvelling at the attitude of the children as they play, one reverencing the other, the colouring of the heads, hands and feet being faultless, and the work of a master. This noble picture is now the property of the heirs of Domenico Canigiani, who value it as a work of Raphael deserves.

This excellent artist studied the old paintings of Masaccio at Florence, and the works of Leonardo and Michelangelo which he saw induced him to study hard, and brought about an extraordinary improvement in his art and style. While at Florence Raphael became very friendly with Fra Bartolommeo of S. Marco, whose colouring pleased him greatly, and this he tried to imitate. On his part he taught the good father the methods of perspective, which he had previously neglected. In the midst of this intimacy Raphael was recalled to Perugia, where he began by finishing the work for Atalanta Baglioni, for which he had prepared the cartoon at Florence, as I have said. This

(1)) Alte Pinakothek, Munich.

divine picture represents Christ carried to burial, so finely done that it seems freshly executed.[1] In composing this work Raphael imagined the grief of loving relations in carrying to burial the body of their dearest, the one on whom all the welfare, honour and advantage of the entire family depended. Our Lady is fainting, and the heads of the figures in weeping are most graceful, especially that of St. John, who hangs his head and clasps his hands in a manner that would move the hardest to pity. Those who consider the diligence, tenderness, art and grace of this painting may well marvel, for it excites astonishment by the expressions of the figures, the beauty of the draperies, and the extreme excellence of every particular.

On returning to Florence after completing this work, Raphael was commissioned by the Dei, citizens there, to paint a picture for the chapel of their altar in S. Spirito.[2] He began this and made good progress with the outline. Meanwhile he did a picture[3] to send to Siena, which at his departure he left to Ridolfo del Ghirlandaio to finish some blue drapery in it. This was

(1) Borghese Gallery, Rome; painted 1507. (2) *The Madonna del Baldacchino*, Pitti Palace, Florence. (3) *La Belle Jardinière*, Louvre, Paris.

Opposite: The Entombment, 1507

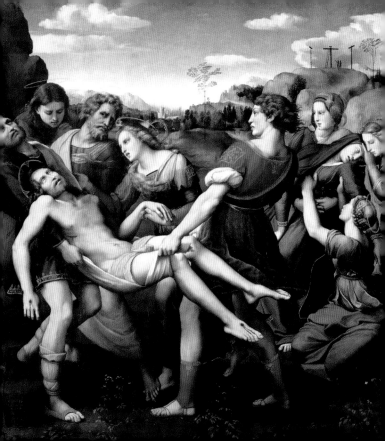

because Bramante, who was in the service of Julius II, wrote to him on account of a slight relationship, and because they were of the same country, saying that he had induced the Pope to have certain apartments done, and that Raphael might have a chance of showing his powers there. This pleased Raphael so that he left his works at Florence and the picture of the Dei unfinished (but so far complete that M. Baldassarre da Pescia had it put in the Pieve of his native place after Raphael's death), and went to Rome. [1] Arrived there, Raphael found a great part of the chambers of the palace already painted, and the whole being done by several masters. Thus Piero della Francesca had finished one scene, Luca da Cortona had completed a wall, while Don Pietro della Gatta, abbot of S. Clemente, Arezzo, had begun some things. Bramantino da Milano also had painted several figures, mostly portraits, and considered very fine. Raphael received a hearty welcome from Pope Julius, and in the chamber of the Segnatura he painted the theologians reconciling Philosophy and Astrology with Theology, including portraits of all the wise men of the world in disputation. [2] Some astrologers there have drawn figures

(1) In 1508 (2) In the following description Vasari has confused in the most astonishing manner the Disputà and the School of Athens.

of their science and various characters on tablets, carried by angels to the Evangelists, who explain them. Among these is Diogenes with a pensive air, lying on the steps, a figure admirable for its beauty and the disordered drapery. There also are Aristotle and Plato, with the *Ethics* and *Timæus* respectively, and a group of philosophers in a ring about them. Indescribably fine are those astrologers and geometricians drawing figures and characters with their sextants. Among them is a youth of remarkable beauty with his arms spread in astonishment and head bent. This is a portrait of Federigo II, Duke of Mantua, who was then in Rome. Another figure bends towards the ground, holding a pair of compasses in his hand and turning them on a board. This is said to be a life-like portrait of Bramante the architect. The next figure, with his back turned and a globe in his hand, is a portrait of Zoroaster. Beside him is Raphael himself, drawn with the help of a mirror. He is a very modest looking young man, of graceful and pleasant mien, wearing a black cap on his head. The beauty and excellence of the heads of the Evangelists are inexpressible, as he has given them an air of attention and carefulness which is most natural, especially in those who are writing.

Overleaf: The School of Athens, 1508-1511

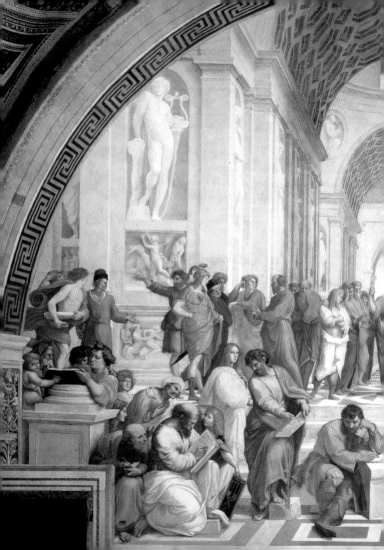

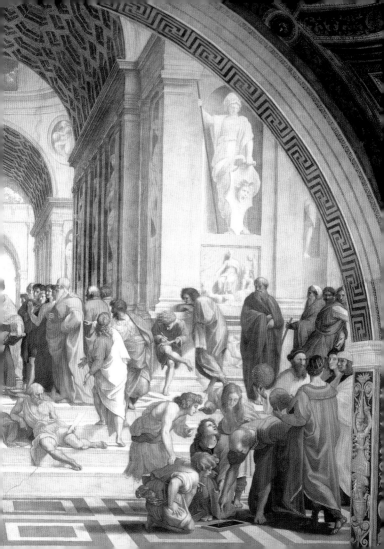

Behind St. Matthew, as he is copying the characters from tablets, held by an angel, is an old man with paper on his knees copying what Matthew dictates. As he stands in that uncomfortable position, he seems to move his lips and head to follow the pen. The minor considerations, which are numerous, are well thought out, and the composition of the entire scene, which is admirably portioned out, show Raphael's determination to hold the field, without a rival, against all who wielded the brush. He further adorned this work with a perspective and many figures, so delicately and finely finished that Pope Julius caused all the other works of the other masters, both old and new, to be destroyed, that Raphael alone might have the glory of replacing what had been done. Although the work of Gio. Antonio Sodoma of Vercelli, which was above the scene of Raphael's, was to have been destroyed by the Pope's order, Raphael decided to make use of its arrangement and of the grotesques. In each of the four circles he made an allegorical figure to point the significance of the scene beneath, towards which it turns. Over the first, where he had painted Philosophy, Astrology, Geometry and Poetry agreeing with Theology, is a woman representing Knowledge, seated in a chair supported on either side by a goddess Cybele, with the numerous breasts ascribed by

the ancients to Diana Polymastes. Her garment is of four colours, representing the four elements, her head being the colour of fire, her bust that of air, her thighs that of earth, and her legs that of water. Some beautiful children are with her. In another circle towards the window looking towards the Belvedere is Poetry in the person of Polyhymnia, crowned with laurel, holding an ancient instrument in one hand and a book in the other. Her legs are crossed, the face having an expression of immortal beauty, the eyes being raised to heaven. By her are two children, full of life and movement, harmonising well with her and the others. On this side Raphael afterwards did the Mount Parnassus above the window already mentioned. In the circle over the scene where the holy doctors are ordering Mass is Theology with books and other things about her, and children of no less beauty than the others. Over the window looking into the court, in another circle, he did Justice with her scales and naked sword, with similar children of the utmost beauty, because on the wall underneath he had represented civil and canon law, as I shall relate. On the same vaulting, at the corners, he did four scenes, designed and coloured with great diligence, though the figures are not large.

Overleaf: Mount Parnassus, finished 1511

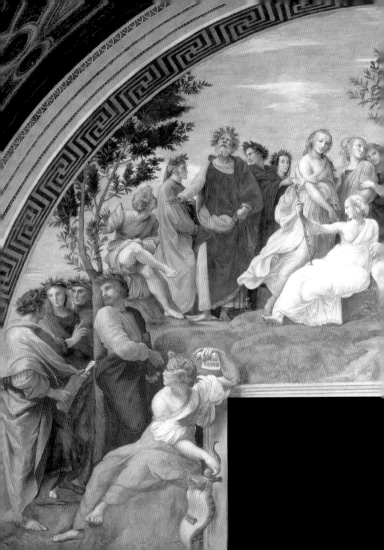

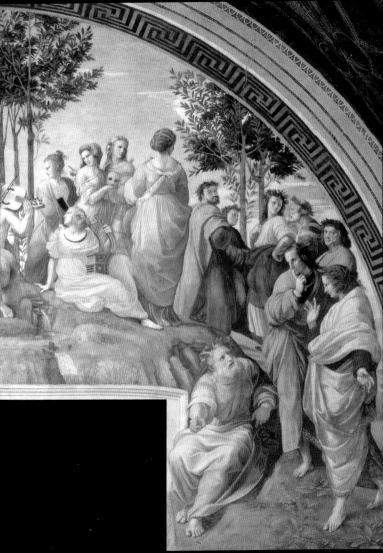

In one of them, next the Theology, he did the sin of Adam in eating the apple, in a graceful style. In the one where Astrology is, he represented that science putting the fixed and moving stars in their appointed places. In the one of Mount Parnassus he did Marsyas flayed at a tree by Apollo; and next the scene of the giving of the Decretals is the Judgment of Solomon. These four scenes are full of feeling and expression, executed with great diligence in beautiful and graceful colouring.

I must now relate what was done on the walls below. On the wall towards the Belvedere, containing the Mount Parnassus and Fountain of Helicon, he made a shady laurel grove about the mount, so that the trembling of the leaves in the soft air can almost be seen, while a number of naked cupids, with lovely faces, are floating above, holding laurel branches, of which they make garlands and scatter them over the mount. The beauty of the figures and the nobility of the painting breathe a truly divine afflatus, and cause those who examine them to marvel that they should be the work of a human mind, through the imperfect medium of colours; and that the excellence of the design should make them appear alive. The poets scattered about the mountain are remarkable in this respect, some standing and some writing, others

talking, and others singing or conversing in groups of four or six according to the disposition. Here are portraits of all the most famous poets, both ancient and modern, taken partly from statues, partly from medals, and many from old pictures, while others were living. Here we see Ovid, Virgil, Ennius, Tibullus, Catullus, Propertius and Homer, holding up his blind head and singing verses, while at his feet is one writing. Here in a group are the nine Muses, with Apollo, breathing realities of wonderful beauty and grace. Here are the learned Sappho, the divine Dante, the delicate Petrarch, the amorous Boccacio, all full of life; Tibaldeo is there also, and numerous other moderns, the whole scene being done with exquisite grace and finished with care. On another wall he did Heaven, with Christ and the Virgin, St. John the Baptist, the Apostles, Evangelists, martyrs in the clouds, with God the Father above sending out the Holy Spirit over a number of saints who subscribe to the Mass and argue upon the Host which is on the altar. Among them are the four Doctors of the Church, surrounded by saints, including Dominic, Francis, Thomas Aquinas, Bonaventura, Scotus, Nicholas of Lyra, Dante, Fra Girolamo Savonarola of Ferrara, and all the Christian theologians, including a number of portraits. In the air are four children holding open the Gospels,

and it would be impossible for any painter to produce figures of more grace and perfection than these. The saints in a group in the air seem alive, and are remarkable for the foreshortening and relief. Their draperies also are varied and very beautiful, and the heads rather celestial than human, especially that of Christ, displaying all the clemency and pity which divine painting can demonstrate to mortal man. Indeed, Raphael had the gift of rendering his heads sweet and gracious, as we see in a Madonna with her hands to her breast contemplating the Child, who looks incapable of refusing a favour. Raphael appropriately rendered his patriarchs venerable, his apostles simple, and his matyrs full of faith. But he showed much more art and genius in the holy Christian doctors, disputing in groups of six, three and two. Their faces show curiosity and their effort to establish, the certainty of which they are in doubt, using their hands in arguing and certain gestures of the body, attentive ears, knit brows, and many different kinds of astonishment, various and appropriate. On the other hand, the four Doctors of the Church, illuminated by the Holy Spirit, solve, by means of the Holy Scriptures, all the questions of the Gospels, which are held by children flying in the air. On the other wall, containing the other window, he did Justinian giving laws to the doctors,

who correct them; above are Temperance, Fortitude and Prudence. On the other side the Pope being a portrait of Julius II, while Giovanni de' Medici the cardinal, afterwards Pope Leo, Cardinal Antonio di Monte, and Cardinal Alessandro Farnese, afterwards Pope Paul III, are also present, with other portraits. The Pope was greatly delighted with this work, and in order to have woodwork of equal value to the paintings, he sent for Fra Giovanni of Verona from Monte Oliveto of Chiusuri, in the Siena territory, then a great master in marquetry. He not only did the wainscoting, but the fine doors and seats with perspectives, which won him favour, rewards and honours from the Pope. Certainly no one was ever more skilful in design and workmanship in that profession than Giovanni, as we see by the admirable perspectives in wood in the sacristy of S. Maria in Organo in his native Verona, the choir of Monte Oliveto di Chiusuri and that of S. Benedetto at Siena, as well as the sacristy of Monte Oliveto of Naples, and the choir in the chapel of Paolo di Tolosa there. Thus he deserves to be held in honour by his order, in which he died at the age of sixty-eight in 1537. I have mentioned him as a man of true excellence, because I think his ability deserves

Overleaf: The Disputà (Debate over the Eucharist), 1508-1511

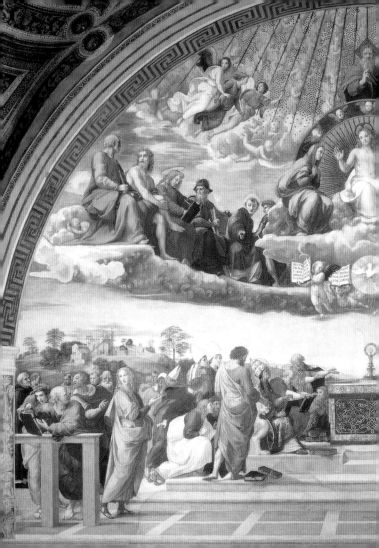

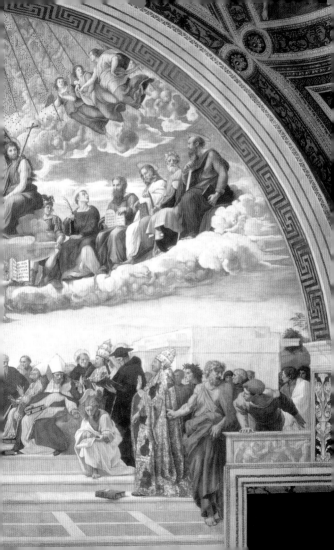

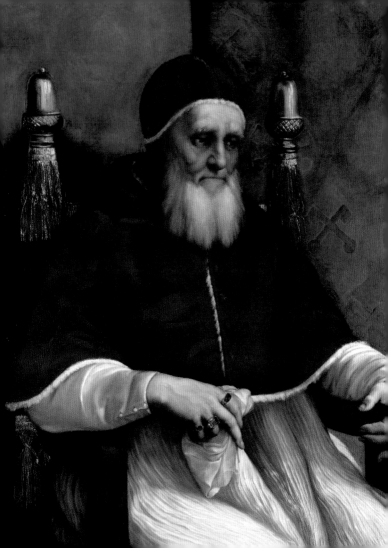

it, for he induced other masters to make many rare works subsequently, as I shall say elsewhere.

But to return to Raphael. His style improved so greatly that the Pope entrusted to him the second chamber towards the great hall. His reputation had now become very great, and at this time he painted a portrait of Pope Julius in oils so wonderfully life-like and true that it inspired fear as if it were alive. This work is now in S. Maria del Popolo,[1] with a fine painting of Our Lady done at the same time, and containing a Nativity of Christ, the Virgin covering the Child with a veil. This is of great beauty, the air of the head and of the whole body showing the Child to be the veritable Son of God. The head and face of the Madonna are of equal beauty, and also display her joy and pity. Joseph leans with both hands on a staff in pensive contemplation of the King and Queen of Heaven, in the wonder of a most holy old man.[2] Both these pictures are shown on solemn festivals.

At this time Raphael had acquired great renown at Rome. But although his graceful style commanded the admiration of all, and he continually studied the numerous antiquities in the city, he had not as yet

(1) National Gallery, London. (2) Musée Condé, Chantilly.

Opposite: Pope Julius II, 1511

endowed his figures with the grandeur and majesty which he imparted to them henceforward.

It happened at this time that Michelangelo caused the Pope so much upset and alarm in the chapel, of which I shall speak in his *Life*, whereby he was forced to fly to Florence. Bramante had the keys of the chapel, and, being friendly with Raphael, he showed him Michelangelo's methods so that he might understand them. This at once led Raphael to do over again the Prophet Isaiah in S. Agostino above the St. Anne of Andrea Sansovino, which he had just finished. Aided by what he had seen of Michelangelo, he greatly improved and enlarged the figure, endowing it with more majesty. When Michelangelo saw it afterwards he concluded that Bramante had played him this bad turn to benefit Raphael. Not long after, Agostino Chigi, a wealthy merchant of Siena and patron of men of genius, allotted to Raphael a chapel, because shortly before he had painted in the sweetest manner, in a loggia of the merchant's palace, now called I Chigi in Trastevere, a Galatea in the sea on car drawn by two dolphins, surrounded by tritons and many sea gods.[1] After making a cartoon for this chapel, which is on the right hand on entering the principal door of the

[1] In the Villa Farnesina; painted in 1514. See Frontispiece.

church of S. Maria della Pace, Raphael carried it out in fresco in a new style, considerably finer and more magnificent than his first. Here he did some Prophets and Sibyls, before the chapel of Michelangelo was opened publicly, though he had seen it, which are considered the best of his works and the most beautiful among so many others, because the women and children are represented with great vivacity and perfect colouring. This work established his renown for ever, as being the most excellent that he produced in his life. At the prayers of a chamberlain of Julius [1] he painted the picture of the high altar of Aracœli, representing Our Lady in the air, a beautiful landscape, St. John, St. Francis and St. Jerome as a cardinal. Our Lady shows the humility and modesty proper to the Mother of Christ, the Child is very prettily playing with his Mother's cloak. St. John shows the effect of fasting, his head expressive of great sincerity and absolute certainty, like those who are far removed from the world, who speak the truth and hate falsehood. St. Jerome raises his head and eyes to Our Lady in contemplation, indicative of the learning and wisdom displayed in his writings; with both hands he

(1) Sigismondo de' Conti. This picture, known as the Madonna di Foligno is now in the Vatican Museums. See illustration overleaf.

is presenting the chamberlain, who is very life-like. Raphael was equally successful with his St. Francis, who kneels on the ground with one arm stretched out, and with his head raised he regards the Virgin, burning with love and emotion, his features and the colouring showing his consuming love and the comfort and life which he derives from regarding her beauty and that of the Child. Raphael did a boy standing in the middle of the picture under the Virgin, looking up to her and holding a tablet. For his beautiful face and well-proportioned limbs he cannot be surpassed. Besides this there is a landscape of remarkable perfection and beauty. Continuing the rooms in the palace, Raphael did the miracle of the Sacrament of the Corporale of Orvieto, or Bolsena, as it is called. [1] We see the priest blushing with shame in saying Mass at seeing the Host melted into blood on the Corporale owing to his incredulity. Fear is in his eyes, and he seems beside himself in the presence of his auditors, as he stands irresolute. His hands tremble, and he shows other signs of terror natural on such an occasion. About him are many varied figures, some serving the Mass, some kneeling on the steps in beautiful

(1) Painted in 1514.

Opposite: The Madonna di Foligno, 1511-12

attitudes, astonished at the event, showing the many various effects of the same emotion, both in the men and women. There is one woman seated on the ground in the lower part of the scene, holding a child in her arms. She turns in wonder at hearing someone speak of what has happened to the priest with a very charming and vivacious feminine grace.

On the other side Raphael represented Pope Julius hearing the Mass, introducing the portrait of the cardinal of S. Giorgio and many others. In the part interrupted by the window he introduced a flight of steps, so that the story is shown entire, and it seems that if this gap had not been there the scene would have suffered. Thus we see that in inventing and composing scenes no one ever excelled Raphael in arrangement and skill. This appears opposite in the same place[1] where St. Peter is represented guarded in prison by armed men, by Herod's order. Here his architecture and his discretion in treating the prison are such that beside him the work of others seem more confused than his are beautiful, for he always endeavoured to follow the narrative in his scenes and introduce beautiful things. Thus, for example, in the horrible prison we see the aged Peter chained between two armed men,

(1) Painted in 1512.

the heavy sleep of the guards, the shining splendour of the angel in the darkness of the night, showing all the details of the cell and making the armour glisten so that it appears to be burnished and not a painted representation. No less art and genius is displayed in the scene where Peter leaves the prison, freed from his chains, accompanied by the angel, the Apostle's face showing that he believes himself to be dreaming. The other armed guards outside the prison are terror-stricken as they hear the sound of the iron door. A sentinel holds a torch in his right hand, the light of which is reflected in all the armour, and where this does not fall there is moonlight. Raphael did this above the window, and thus makes the wall darker. But in looking at the picture, the painted light and the various lights of the night seem due to Nature, so that we fancy we see the smoke of the torch, the splendour of the angel, and the deep darkness of the night, so natural and true that it is hard to believe they are only painted, where every difficult thing that he has imagined is so finely presented. Here in the darkness we see the outlines of the armour, the shading, the reflections, the effects of the heat of the lights, showing Raphael to be the master of the other painters. No better representation of

Overleaf: The Liberation of St Peter , 1511-14

65

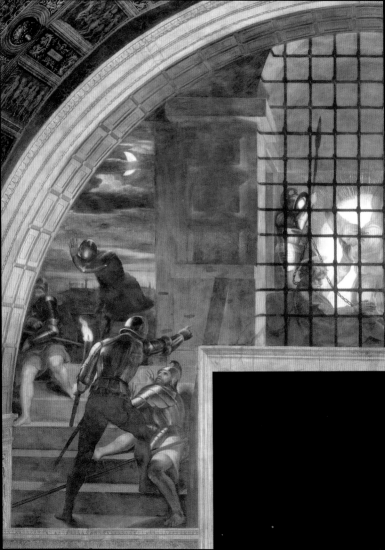

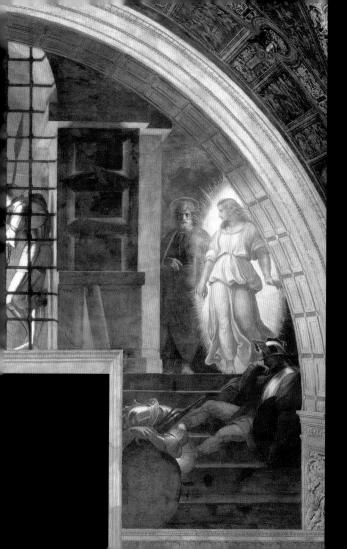

the night has ever been made, this being considered the divinest and most remarkable of all.

On one of the bare walls Raphael further did the Divine worship, the Ark of the Hebrews and the candlestick, and Pope Julius driving Avarice from the church, scenes of beauty and excellence like the night just mentioned. They contain portraits of the bearers then living, who are carrying the Pope in a chair, for whom some men and women make way to allow him to pass. An armed man on horseback, accompanied by two on foot, is fiercely striking the proud Heliodorus, who, by the command of Antiochus, intended to despoil the Temple of all the deposits of widows and orphans. We see the property and treasures being taken away, but all thrown to the ground and scattered at the fall of Heliodorus, beaten to the earth by the three, whom he alone sees, those engaged in carrying them being seized with sudden terror like all the other followers of Heliodorus. Apart from these kneels the High Priest Onias in his pontificals, his eyes and hands turned to heaven in fervent prayer, filled with compassion for the poor who are losing their possessions, and with joy at the succour sent by Heaven. By a happy idea of Raphael the plinths of the pedestals are filled with many who have climbed up by the columns, and are looking on in their uneasy postures, while the

astonished multitude, in various attitudes, is awaiting the event. This work is so marvellous in every particular that even the cartoons for it are greatly prized. Some parts of them belong to M. Francesco Masini, a nobleman of Cesena, who, without the help of any Masters but guided from his childhood by an extraordinary natural instinct, has himself studied painting and produced pictures which are much admired by connoisseurs. These cartoons are among his designs with some ancient reliefs in marble, and are valued by him as they deserve. I must add that M. Niccolo Masini, who has supplied me with these particulars, is a genuine admirer of our arts as he is distinguished in every other particular.

But to return to Raphael. In the vaulting of this chamber he did four scenes: the appearance of God to Abraham, promising the multiplication of his seed, the sacrifice of Isaac, Jacob's ladder, and the burning bush of Moses, displaying no less art, invention, design and grace than in his other works. While he was engaged in producing these marvels, envious Fortune deprived Julius II of his life, removing that patron of talent and admirer of every good thing. On Leo X

Overleaf: The Expulsion of Heliodorus from the Temple, 1511-14

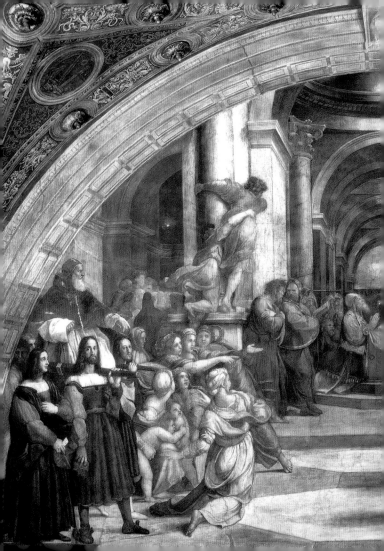

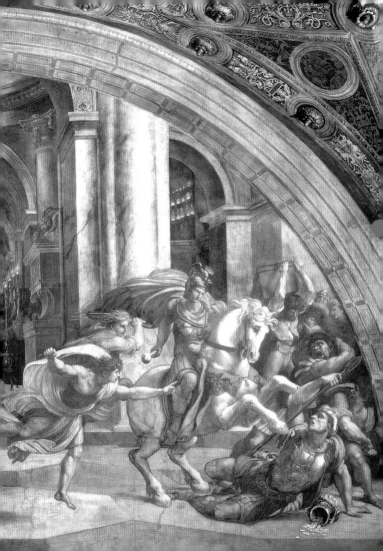

succeeding[1]. he wished the work to be continued. Raphael's abilities ascended to the heavens, and he was much gratified at meeting so great a prince, who inherited the love of his family for the arts. Accordingly he was heartened to continue the work, and on the other wall did the coming of Attila to Rome, and his meeting with Leo III at the foot of Monte Mario, and being driven away with a simple benediction. In the air are St. Peter and St. Paul with drawn swords coming to defend the Church. Although the history of Leo III does not relate this, the artist no doubt wished it to be so, just as the poets often introduce some fresh matter to their work as an ornament, and yet do not depart from the main idea. The Apostles show a valour and celestial ardour that the divine judgment often puts into the faces of its servants to defend the most holy religion. Attila, mounted on a black horse of the utmost beauty with a white star on his forehead, betrays great fear in his face as he takes to flight. There are other very fine horses, notably a dappled Spanish jennet, ridden by a man whose bare parts are covered with scales like a fish. He is copied from Trajan's Column, where the men are armed in this way, and it is supposed to be made of crocodile skin.

(1) Giovanni de' Medici, elected 13 February 1553.

Monte Mario is burning, showing that on the departure of soldiers their quarters are always left in flames. Raphael also drew some mace-bearers accompanying the Pope, who are very life-like, and the horses they ride, with the court of the cardinals and other bearers, holding the hackney, upon which the man in pontificals is mounted, who is a portrait of Leo X, as fine as the others, and many courtiers. This is a truly charming thing, thus adapted to such a work, and most useful to our art, especially for those who delight in such things. At the same time Raphael did a panel for Naples which was placed in S. Domenico in the chapel containing the crucifix which spoke to St. Thomas Aquinas. It represents the Virgin, St. Jerome dressed as a cardinal, and the Angel Raphael accompanying Tobias. [1] He did a picture for Leonello da Carpi, lord of Meldola, who is still alive, though over ninety. This was a marvel of colouring and of singular beauty, being executed with vigour and of such delicate loveliness that I do not think it can be improved upon. The face of the Madonna expresses divinity and her attitude modesty. With joined hands she adores her Child, who sits on her knees and is caressing a little St. John, who adores him, as do St. Elizabeth and Joseph. This

(1) Madonna del Pesce, now in the Prado, Madrid.

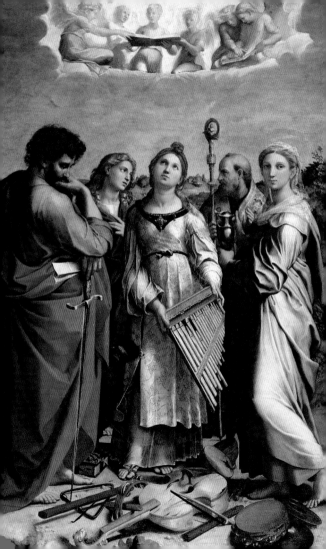

picture belonged to the Cardinal di Carpi, son of Leonello, a distinguished patron of the arts, and it must now be in the possession of his heirs. [1] When Lorenzo Pucci, cardinal of Sante Quattro, was appointed chief penancer, Raphael obtained a commission from him to do a picture for S. Giovanni in Monte at Bologna. It is now placed in the chapel containing the body of the Blessed Elena dall' Olio. [2] In this work we see the full power of the delicate grace of Raphael joined to art. St. Cecilia listens entranced to a choir of angels in heaven, absorbed by the music. Her face is abstracted like one in an ecstasy, on the ground musical instruments are scattered, which look real and not painted, as do her veil and vestments of cloth of gold and silk, with a marvellous haircloth beneath. St. Paul rests his right arm on a naked sword and his head on his hand, showing his knowledge and his fiery nature turned to gravity. He is bare-footed and dressed like an apostle in a simple red mantle, with a green tunic beneath. St. Mary Magdalene lightly holds a vase of precious stone in her hand, and turns her head in joy at her

(1) Museo di Capodimonte, Naples. (2) Pinacoteca Nazionale, Bologna; painted 1513.

Opposite: St. Cecilia with Sts Paul, Catherine, Augustine and Mary Magdalene, 1518

conversion; these are of unsurpassable beauty, and so are the heads of St. Augustine and St. John the Evangelist. While we may term other works paintings, those of Raphael are living things; the flesh palpitates, the breath comes and goes, every organ lives, life pulsates everywhere, and so this picture added considerably to his reputation. Thus many verses were written in his honour in the vulgar and Latin tongues. I will quote the following only, not to make my story too long:

> Pingant sola alii referantque coloribus ora;
> Cæciliæ os Raphael atque animum explicuit. [1]

After this Raphael did a small picture of little figures, also at Bologna, in the house of Count Vincenzio Ercolani, containing Christ, as Jove, in heaven, surrounded by the four Evangelists as described by Ezekiel, one like a man, one as a lion, one as an eagle and one as an ox, with a landscape beneath, [2] no less beautiful for its scale than the large works. To the counts of Canossa at Verona he sent a large picture of equal excellence of Nativity, with a much admired

(1) 'Others may paint only the sitter's face, and catch its colour; / Raphael reveals Cecilia's very mind.' (2) Palazzo Pitti, Florence

Opposite: Vision of Ezekiel, c. 1518

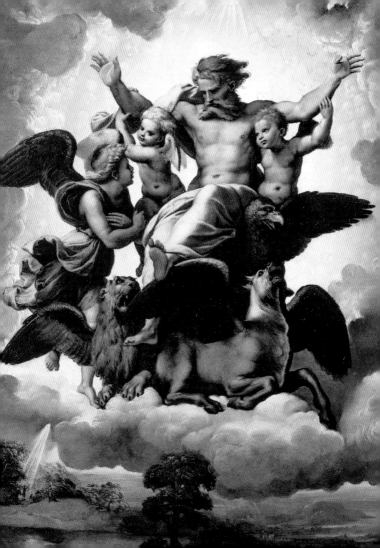

Dawn, and a St. Anne. Indeed, the whole work is fine, and to say that it is by Raphael is to bestow the highest praise, and it is greatly prized by the counts. Though offered great sums by many princes they have refused to part with it. For Bindo Altoviti Raphael did his portrait as a young man,[1] considered most wonderful. He also did a picture of the Virgin, which he sent to Florence.[2] This is now in the palace of Duke Cosimo in the chapel of the new apartments built and painted by myself, where it serves as the altarpiece. It represents an aged St. Anne seated, offering the Christchild to the Virgin, the baby being a beautiful nude figure with a lovely face that gladdens all beholders by its smile. Raphael in painting this Madonna shows with what beauty art can endow the aspect of a Virgin, with her modest eyes, her noble forehead, her graceful nose and her virtuous mouth, while her dress displays the utmost simplicity and virtue. Indeed, I do not think a better can be seen. There is a nude St. John, seated, and a very beautiful female saint. The background is a house with a window lighting the room in which the figures are. At Rome Raphael did

(1) National Gallery of Art, Washington. (2) Now known as the Madonna dell'Impannata; in the Pitti Palace, Florence.

Opposite: Portrait of Bindo Altoviti, 1515

a picture with the portraits of Pope Leo, Cardinal Giulio de' Medici and and the Cardinal de' Rossi.[1] The figures seem to stand out in relief; the velvet shows its texture, the damask on the Pope is shining and lustrous, the fur lining soft and real, and the gold and silk look like the actual materials and not colours. There is an illuminated parchment book, of remarkable realism, and a bell of chased silver of indescribable beauty. Among other things is the burnished gold ball of the seat, reflecting, such is its clearness, the lights of the windows, the Pope's back, and the furniture of the room like a mirror, so wonderfully done that it would seem that no master can improve upon it. For this work the Pope largely rewarded him, and the picture is still in Florence in the duke's wardrobe. He also painted Duke Lorenzo and Duke Giuliano as finely as these, with equal grace in the colouring. These are in the possession of the heirs of Ottaviano de' Medici in Florence. Thus the glory and the rewards of Raphael increased together. To leave a memory of himself he built a palace in the Borgo Nuovo at Rome, decorated with stucco by Bramante.

By these and other works the fame of Raphael

(1) Uffizi, Florence.

Opposite: Pope Leo X and Cardinals, 1518

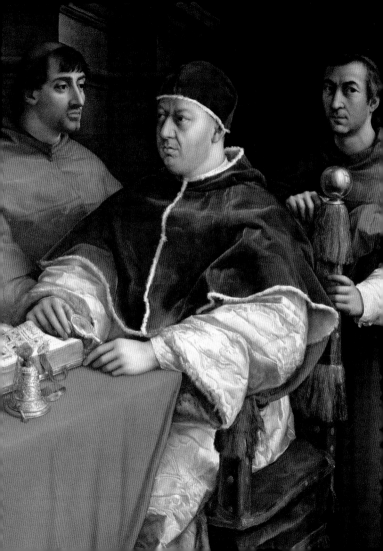

spread to France and Flanders. Albert Dürer, a re-
markable German painter and author of some fine
copper engravings, paid him the tribute of his hom-
age and sent him his own portrait, painted in water-
colours, on cambric, so fine that it was transparent,
without the use of white paint, the white material
forming the lights of the picture This appeared mar-
vellous to Raphael, who sent back many drawings of
his own which were greatly valued by Albert.[1] This
head was among the things of Giulio Romano, Raph-
ael's heir, in Mantua.

Having seen the engravings of Albert Dürer,
Raphael was anxious to show what he could do in
that art, and caused Marco Antonio of Bologna to
study the method. He succeeded so well that he had
his first things engraved: the Innocents, a Last Sup-
per, a Neptune, the St. Cecilia[2] boiled in oil. Marco
Antonio then did a number of prints which Raphael
afterwards gave to Il Baviera, his boy, who had the
charge of one of his mistresses whom Raphael loved
until his death. He made a beautiful life-like portrait
of her which is now in Florence in the possession
of the most noble Botti, a Florentine merchant, the

(1) One of these is in the Albertina, Vienna. (2) Actually S. Felicita

Opposite: 'La donna velata' (Raphael's mistress), 1514-15

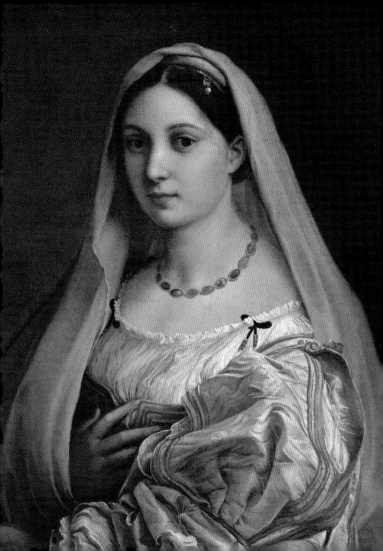

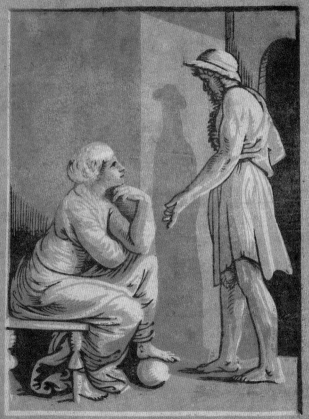

friend and intimate of all distinguished men, especially painters. [1] He keeps it as a reminder of his love for art and especially of Raphael. His brother Simone Botti is not behind him in his love of art, and besides his reputation among artists as one of the best patrons of their profession, he is especially esteemed by me as the best friend I have ever had, while he possesses a good artistic judgment.

But to return to engravings. The favour of Raphael to Il Baviera quickened the hand of Marco da Ravenna so that copper engravings from being scarce became as plentiful as we now see them. Then Ugo da Carpi, a man whose head was full of ingenious ideas and fancies, discovered wood engraving, so that by three impressions he obtained the light and the shade of chiaroscuro sketches, a very beautiful and ingenious invention. Quantities of these prints may now be seen, as I shall relate in more in detail, in the Life of Marco Antonio of Bologna. For the monastery of Palermo, called S. Maria dello Spasmo, of the friars of Monte Oliveto, Raphael did Christ bearing the Cross, which is considered marvellous, seeing the

(1) 'La donna velata', Pitti Palace, Florence

Opposite: Chiaroscuro print by Ugo da Carpi, called Raphael and his Mistress, 1510-20

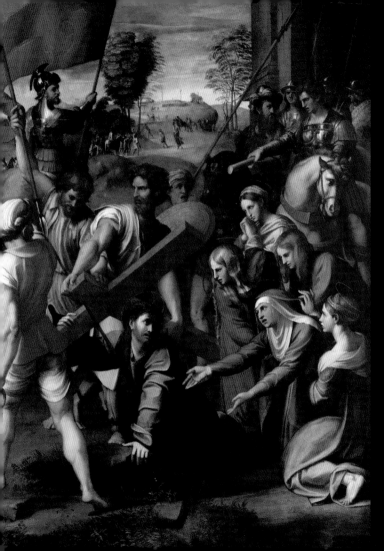

cruelty of the executioners leading Him to death on Mount Calvary with fierce rage.[1] The Christ in his grief and pain at the approach of death has fallen through the weight of the cross, and, bathed in sweat and blood, turns towards the Maries, who are weeping bitterly. Here Veronica is stretching out her hand and offering the handkerchief with an expression of deep love. The work is full of armed men on horse and foot, who issue from the gate of Jerusalem with the standards of justice in their hands, in varied and fine attitudes. When this picture was finished, but not set up in its place, it was nearly lost, because on its way by sea to Palermo a terrible storm overtook the ship, which was broken on a rock, and the men and merchandise all perished, except this picture, which was washed up at Genoa in its case. When it was fished out and landed it was found to be a divine work, and proved to be uninjured, for even the fury of the winds and waves respected such painting. When the news had spread, the monks hastened to claim it, and no sooner was it restored to them through the influence of the Pope than they handsomely rewarded those

(1) Christ on the Road to Calvary (the 'Spasmo di Sicilia'), Prado Museum, Madrid. Vasari is confused about Veronica.

Opposite: Christ on the road to Calvary, the 'Spasmo di Sicilia', 1515-16

who had saved it. It was again sent by ship, and was set up in Palermo, where it is more famous than the mountain of Vulcan. While Raphael was at work on these things, which he had to do, since it was for great and distinguished persons, and he could not decline them in his own interest, he nevertheless continued his work in the Pope's chambers and halls, where he kept men constantly employed in carrying on the work from his designs, while he supervised the whole, giving assistance as he well knew how. It was not long before he threw open the chamber of the Borgia tower. On every wall he painted a scene, two above the windows and two others on the sides. During a fire in the Borgo Vecchio at Rome, which could not be put out, St. Leo IV had gone to the loggia of the palace and extinguished it with a benediction. This scene represents various perils. In one part we see women whose hair and clothes are blown about by the fury of the wind, as they carry water to extinguish the fire in vessels in their hands and on their heads. Others endeavouring to cast water are blinded by the smoke. On the other side is a sick old man, beside himself with infirmity and the conflagration, borne as Virgil

Opposite: Study for Fire in the Borgo, 1513-14

Overleaf: The Fire in the Borgo, 1514-17

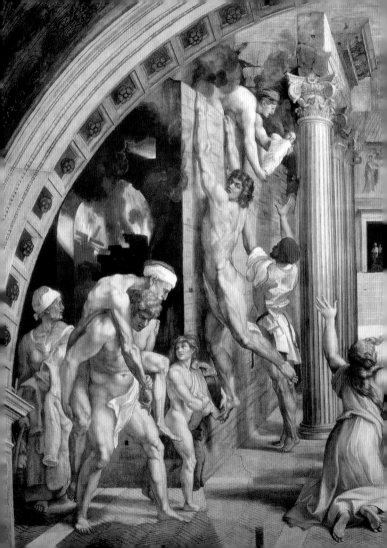

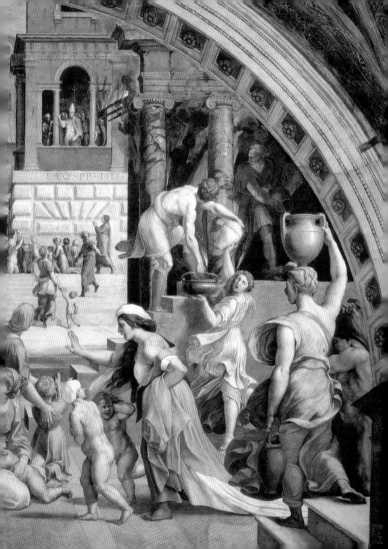

describes Anchises to have been borne by Æneas, the youth showing his spirit and putting out his strength to carry his burden. A lean, bare-footed old woman follows them, fleeing from the fire, with a naked child before them. From the top of some ruins is a naked, dishevelled woman, who throws her child to one who has escaped from the flames and stands on tip-toe in the street, with arms stretched out to receive the little one in its swaddling-clothes. The desire of the woman to save the child and her own fear of the approaching fire are well depicted, while the one receiving the child is disturbed by fear for his own safety while anxious to save his charge. Equally remarkable is a mother, dishevelled and ragged, with some clothes in her hand, who beats her children to make them run faster from the fire. Some women kneeling before the Pope seem to be begging him to cause the fire to cease.

The other scene[1] is also of St. Leo IV, where he has represented the port of Ostia, occupied by the Turks, who came to make him prisoner. We see the Christians fighting the fleet at sea, a number of prisoners already taken to the port, coming out of a boat, led by soldiers by the beard, the attitudes being very fine. In their varying costumes they are led by galley-slaves

(1) Begun in 1514.

before St. Leo, who is a portrait of Leo X, the Pope standing in his pontificals between Bernardo Dovizi of Bibbiena, the Cardinal S. Maria in Portico, and Cardinal Giulio de' Medici, afterwards Pope Clement. I cannot relate at length the numerous fine devices employed by the artist in representing the prisoners, and how, without speech, he represents grief, fear and death. There are two other scenes, one[1] of Leo X consecrating the Most Christian King Francis I of France, singing the Mass in his pontificals and blessing the anointing oil, with a number of cardinals and bishops in pontificals assisting, including the portraits of several ambassadors and others, some dressed in the French fashion of the time. The other scene is the coronation of the king, the Pope and Francis being portraits, the one in armour and the other in pontificals.[2] All the cardinals, bishops, chamberlains, squires, grooms of the chamber, are in their robes, and seated according to rank, after the custom of the chapel, and are portraits, including Giannozzo Pandolfini, bishop of Troyes, a great friend of Raphael, and many other noted men of the time. Near the king is a boy kneeling and holding the royal crown. This is a portrait of

(1) In fact this scene shows the Oath of Leo III
(2) Dated 1517, the scene shows the Coronation of Charlemagne.

Ippolito de' Medici, who afterwards became cardinal and vice-chancellor, and a great friend of the arts and other talents. To his memory I acknowledge my indebtedness, for it is to him that I owe my start on my career, such as it has been. I cannot enter into every minute detail concerning the productions of this artist whose very silence is like speech. Beneath these scenes are figures of the defenders and benefactors of the Church, each surrounded by a different border and everything carried out with spirit, expression and good ideas, with a harmony of colours that cannot be described. As the vaulting of this room was painted by Pietro Perugino, his master, Raphael would not efface it, from respect for the memory of him who had taught him the first elements of his art.

Such was the greatness of this man that he kept draughtsmen in all Italy, at Pozzuolo, and as far as Greece, to procure everything of value to assist his art. Continuing his series, he did a room with some figures on the ground level of apostles and saints in tabernacles, and employed Giovanni da Udine, his pupil, unique in drawing animals, to do all the animals of Pope Leo: a chameleon, the civet cats, apes, parrots, lions, elephants, and other curious creatures. He further decorated the palace with grotesques and varied pavements, designing the papal staircases and

other loggia begun by Bramante the architect, but left unfinished at his death. Raphael followed a new design of his own, and made a wooden model on a larger scale and more ornate than Bramante's. As Pope Leo wished to display his magnificence and generosity, Raphael prepared the designs for the stucco ornaments and the scenes painted there, as well as of the borders. He appointed Giovanni da Udine head of the stucco and grotesque work, and Giuliano da Romano of the figures, though he did little work on them. Gio. Francesco, also Il Bologna, Perino del Vaga, Pellegrino da Modena, Vincenzio da S. Gimignano, and Polidoro da Caravaggio, with many other painters, did scenes and figures and other things for that work, which Raphael finished with such perfection that he sent to Florence for a pavement by Luca della Robbia. Certainly no finer work can be conceived, with its paintings, stucco, disposition and inventions. It led to Raphael's appointment as superintendent of all works of painting and architecture done in the palace. It is said that his courtesy was so great that the builders, to allow him to accommodate his friends, did not make the walls solid, but left openings above the old rooms in the basement, where they might store casks, pipes and firewood. These openings enfeebled the base of the structure, so that it became necessary to fill them

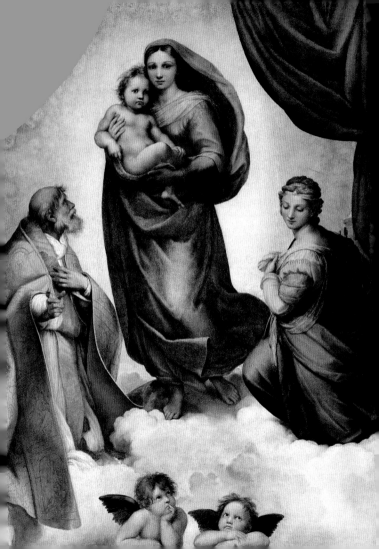

up owing to the cracks which began to show. For the gracefully finished inlaid work of the doors and wainscoting of these rooms Raphael employed Gian Barile, a clever woodcarver. He prepared architectural designs for the Pope's villa, and for several houses in the Borgo, notably the palace of M. Gio. Battista dall' Aquila, which was very beautiful. He did another for the bishop of Troyes in the via di S. Gallo in Florence. For the black monks of S. Sisto at Piacenza he did the high altar picture representing the Madonna, with St. Sixtus and St. Barbara, a rare and unique work. [1] He did many pictures for France, notably a St. Michael fighting the devil, [2] for the king, considered marvellous. He represented the centre of the earth by a half-burned rock, from the fissures of which issue flames of fire and sulphur. Lucifer, whose burned members are coloured several tints, exhibits his rage and his poisoned and inflated pride against Him who has cast him down, and his realisation of his doom of eternal punishment. Michael, on the other hand, is of celestial aspect, in armour of iron and gold, courageous and strong, having already overthrown Lucifer,

(1) The Sistine Madonna, Gemäldegalerie, Dresden. (2) Dated 1518; Louvre, Paris. See illustration overleaf

Opposite: The Sistine Madonna, 1512-13

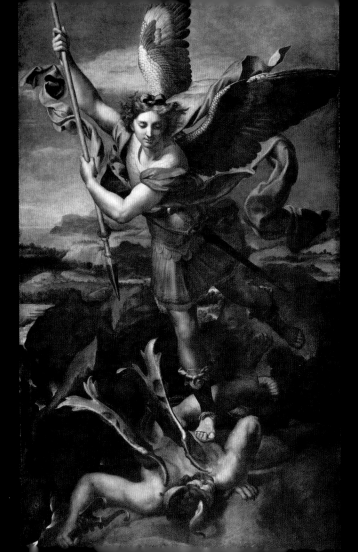

at whom he aims his spear. In fine, this work deserved a rich reward from the king. He drew portraits of Beatrice of Ferrara and other ladies, including his own mistress.

Raphael was very amorous, and fond of women, and was always swift to serve them. Possibly his friends showed him too much complaisance in the matter. Thus, when Agostino Chigi, his close friend, employed him to paint the first loggia in his palace, Raphael neglected the work for one of his mistresses. Agostino, in despair, had the lady brought to his house to live in the part where Raphael was at work, contriving this with difficulty by the help of others. That is why the work was completed. Raphael did all the cartoons of this work, and coloured many figures in fresco with his own hand. In the vaulting he did the council of the gods in heaven, introducing forms and costumes borrowed from the antique, with refined grace and design. Thus he did the espousal of Psyche, with the ministers who serve Jove, and the Graces scattering flowers. In the lower part of the vaulting he did many scenes, including Mercury with the flute, who seems to be cleaving the sky in his

Opposite: Saint Michael slaying the devil, 1518

Overleaf: Loggia di Psiche, Wedding Banquet of Cupid and Psyche, 1517

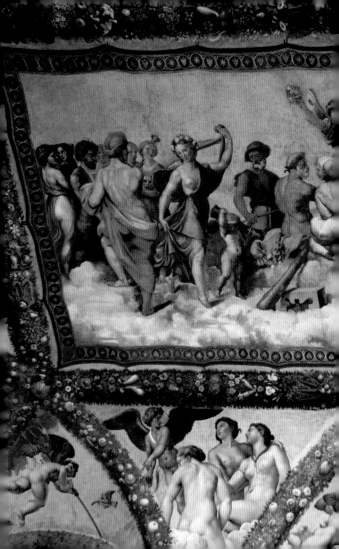

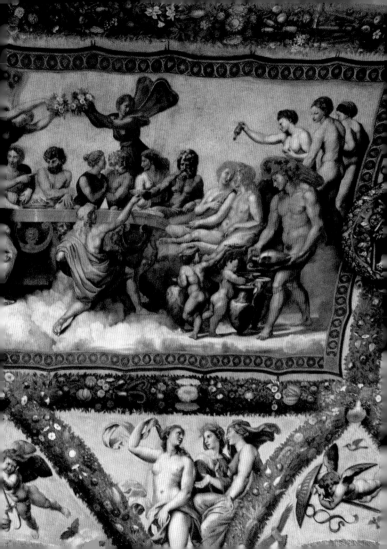

flight. In another, Jove, with celestial dignity, is kissing Ganymede. Beneath is the chariot of Venus and Mercury, and the Graces taking Psyche to heaven, with many other poetical scenes. In the arched space between the corbels he did a number of cherubs, beautifully foreshortened, carrying the implements of the gods in their flight: the thunderbolts and arrows of Jove, the helmet, sword and target of Mars, the hammers of Vulcan, the club and lion's skin of Hercules, the wand of Mercury, the pipe of Pan, the agricultural rakes of Vertumnus, all with animals appropriate to their nature, a truly beautiful painting and poem. As a border to these scenes he caused Giovanni da Udine to make flowers, leaves and fruits in festoons, which could not be better.[1] He designed the architecture of the stables of the Chigi, and Agostino's chapel in the church of S. Maria del Popolo, where, besides the painting, he designed a marvellous tomb, directing Lorenzetto, a sculptor of Florence, to make two figures, which are still in his house in the Macello de' Corbi at Rome; but the death of Raphael, followed by that of Agostino, led to the work being given to Sebastiano Veneziano.

(1) The Farnesina was decorated in 1517-18 with assistance from Giovanni Francesco Penni, Giulio Romano and Giovanni da Udine. Paintings are still in situ.

Raphael had become so great that Leo X ordained that he should begin the large upper hall, containing the Victories of Constantine, which he began. The Pope also desired to have rich tapestry hangings of gold and silk. For these Raphael made large coloured cartoons of the proper size, all with his own hand, which were sent to weavers in Flanders,[1] and, when finished, the tapestries came to Rome. The work is so marvellously executed that it excites the wonder of those who see it that such things as hair and beards and delicate flesh-colouring can be woven work. It is certainly a miracle rather than a production of human art, containing, as it does, water, animals, buildings, all so well done that they seem the work of the brush and not of the loom. It cost 70,000 crowns, and is still preserved in the papal chapel. For the Cardinal Colonna Raphael did a St. John on canvas, greatly prized by its owner, who, falling sick, gave it to the physician who healed him, M. Jacopo da Carpi, feeling under a great obligation, and it is now in Florence in the hands of Francesco Benintendi.[2] For Cardinal

(1) The cartoons were done in 1515 or 1516. They were bought by Charles I in 1630 and are now in the Victoria and Albert Museum. The tapestries are in the Vatican Museums. (2) Uffizi, Florence.

Overleaf: Tapestry cartoon for The Miraculous Draught of Fishes, c. 1515-16

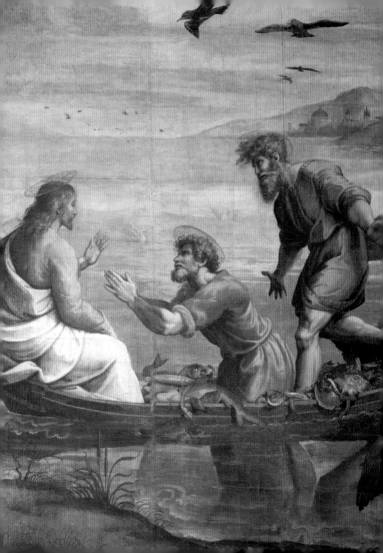

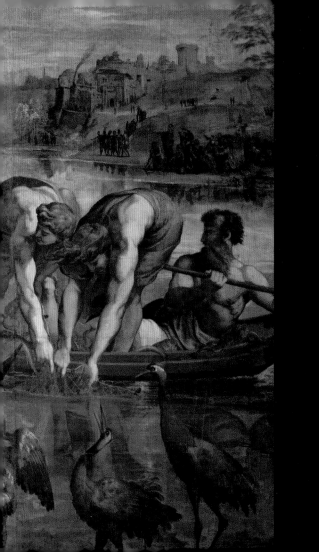

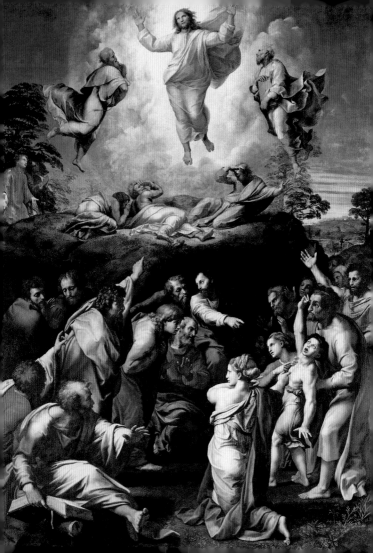

Giulio de' Medici, the vice-chancellor, he painted the Transfiguration, to be sent to France. He worked steadily at this with his own hands, bringing it to its final completion.[1] It represents Christ transfigured on Mount Tabor with the eleven disciples at the foot, awaiting their Master. A boy possessed by a devil is brought so that Christ when he has come down from the mount may release him. The sufferings of this boy through the malignity of the spirit are apparent in his flesh, veins and pulse, as he thrusts himself forward in a contorted attitude, shouting and turning up his eyes, while his pallor renders the gesture unnatural and alarming. An old man is embracing and supporting him, his eyes shining, his brows raised, and his forehead knit, showing at once his resolution and fear. He steadily regards the Apostles, as if to derive courage from them. A woman there, the principal figure of the picture, kneels in front of the Apostles, and is turning her head towards them, while she points out the misery of the boy possessed. The Apostles, standing, sitting and kneeling, show their great compassion for this great misfortune. Indeed, the figures and heads are of extraordinary beauty, and so new

(1) Vatican Museums

Opposite: The Transfiguration, 1516-20

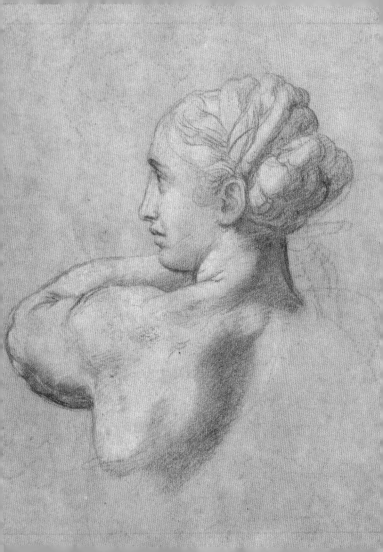

and varied that artists have commonly reputed this work the most renowned the most beautiful and the most divine. Whoever wishes to imagine and realise the transfiguration of Christ should examine this work, where the Lord is in the shining air, with Moses and Elias illuminated by His splendour. Prostrate on the ground lie Peter, James and John in varied and beautiful attitudes. One has his head on the ground, one shades his eyes with his hands from the rays of light of the splendour of Christ, who, clothed in snow white, opens His arms and lifts His head, showing the Divine Essence of the three persons of the Trinity thus displayed in the perfection of Raphael's art. The artist seems to have gathered all his force to worthily present the face of Christ, which was the last thing he did, as death overtook him before he again took up the brush.

Having hitherto described the works of this great man, I will make some observations on his style for the benefit of our artists, before I come to the other particulars of his life and death. In his childhood Raphael imitated the style of Pietro Perugino, his master, improving it greatly in design, colouring and invention. But in riper years he perceived that this was

Opposite: Study of a Head and Left Shoulder of a Woman, 1519-20

too far from the truth. For he saw the works of Leonardo da Vinci, who had no equal for the fashion of the heads of women and children, and in rendering his figures graceful, while in movement he surpassed all other artists; these filled Raphael with wonder and amazement. As this style pleased him more than any he had ever seen, he set to work to study it, and gradually and painfully abandoning the manner of Pietro, he sought as far as possible to imitate Leonardo. But in spite of all his diligence and study he could never surpass Leonardo, and though some consider him superior in sweetness, and in a certain natural facility, yet he never excelled that wonderful groundwork of ideas, and that grandeur of art, in which few have equalled Leonardo. Raphael, however, approached him more closely than any other painter, especially in grace of colouring.

But to return to Raphael himself. The style which he learnt of Pietro when young became a great disadvantage to him. He had learned it readily because it was slight, dry and defective in design, but his not being able to throw it off rendered it very difficult for him to learn the beauty of nudes, and the method of difficult foreshortening of the cartoon of Michelangelo Buonarroti for the Hall of the Council at Florence. Another man would have lost heart at

having wasted so much time, but not so Raphael, who purged himself of the style of Pietro, and used it as a stepping-stone to reach that of Michelangelo, full as it was of difficulties in every part. The master having thus become a pupil again, applied himself to do as a man in a few months the work of several years, at an age when one learns quickly. Indeed, he who does not learn good principles and the style which he means to follow at an early age, acquiring facility by experience, seeking to understand the parts and put them in practice, will hardly ever become perfect, and can only do so with great pains, and after long study. When Raphael began to change and improve his style, he had never studied the nude as it should be studied, but had only done portraits as he had seen his master Pietro do them, assisted by his own natural grace. Accordingly he studied the nude, comparing the muscles of dead men with those of the living, which do not seem so marked when covered with skin as they do when the skin is removed. He afterwards saw how the soft and fleshy parts are made, and graceful turnings and twists, the effects of swelling, lowering and raising a member or the whole body, the system of bones, nerves and veins, becoming excellent in all the parts as a great master should. But seeing that he could not in this respect attain to the perfection of Michelangelo,

and being a man of good judgment, he reflected that painting does not consist of representing nude figures alone, but that it has a large field, and among the excellent painters there were many who could express their ideas with ease, felicity and good judgment, composing scenes not overcrowded or poor, and with few figures, but with good invention and order, and who deserved the name of skilled and judicious artists. It was possible, he reflected, to enrich his works with variety of perspective, buildings and landscapes, a light and delicate treatment of the draperies, sometimes causing the figure to be lost in the darkness, and sometimes coming into the clear light, making living and beautiful heads of women, children, youths and old men, endowing them with suitable movement and vigour. He also reflected upon the importance of the flight of horses in battle, the courage of the soldiers, the knowledge of all sorts of animals, and, above all, the method of drawing portraits of men to make them appear life-like and easily recognised, with a number of other things, such as draperies, shoes, helmets, armour, women's head-dresses, hair, beards, vases, trees, caves, rain, lightning, fine weather, night, moonlight, bright sun, and other necessities of present-day painting. Reflecting upon these things, Raphael determined that, if he could not equal Michelangelo in

some respects, he would do so in the other particulars, and perhaps surpass him. Accordingly he did not imitate him, not wishing to lose time, but studied to make himself the best master in the particulars mentioned. If other artists had done this instead of studying and imitating Michelangelo only, though they could not attain to such perfection, they would not have striven in vain, attaining a very hard manner full of difficulty, without beauty or colouring, and poor in invention, when by seeking to be universal, and imitating other parts, they might have benefited themselves and the world. Having made this resolution, and knowing that Fra Bartolommeo of S. Marco had a very good method of painting, solid design and pleasant colouring, although he sometimes used the shadows too freely to obtain greater relief, Raphael borrowed from him what he, thought would be of service, namely a medium style in design and colouring, combining it with particulars selected from the best things of other masters. He thus formed a single style out of many, which was always considered his own, and was, and will always be, most highly esteemed by artists. This is seen to perfection in the sibyls and prophets done in S. Maria della Pace, as has been said, for which he derived so much assistance from having seen the work of Michelangelo in the Pope's chapel. If Raphael had

stopped here, without seeking to aggrandise and vary his style, to show that he understood nudes as well as Michelangelo, he would not have partly obscured the good name he had earned, for his nudes in the chamber of the Borgia tower in the Burning of the Borgo Nuovo, though good, are not flawless. Equally unsatisfactory are those done by him on the vaulting of the palace of Agostino Chigi in Trastevere, because they lack his characteristic grace and sweetness. This was caused in great measure by his having employed others to colour from his designs. Recognising this mistake, he did the Transfiguration of S. Pietro in Montorio by himself unaided, so that it combines all the requisites of a good painting. If he had not employed printers' lampblack, through some caprice, which darkens with time, as has been said, and spoils the other colours with which it is mixed, I think the work would now be as fresh as when he did it, whereas it has now become rather faded.

I have entered upon these questions at the end of this Life to show how great were the labours, studies and diligence of this famous artist, and chiefly for the benefit of other painters, so that they may rise superior to disadvantages as Raphael did by his prudence

Opposite: Study for the head of a young Apostle, c. 1516-20

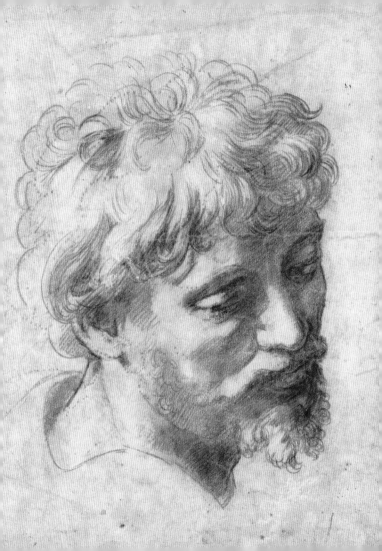

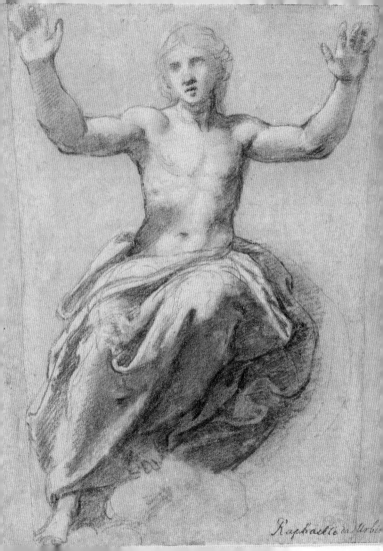

Raphaelle in Urb

and skill. Let me also add that everyone should be contented with doing the things for which he has a natural bent, and ought not to endeavour out of emulation to do what does not come to him naturally, in order that he may not labour in vain, frequently with shame and loss. Besides this, he should rest contented and not endeavour to surpass those who have worked miracles in art through great natural ability and the especial favour of God. For a man without natural ability, try how he may, will never succeed like one who successfully progresses with the aid of Nature. Among the ancients Paolo Uccello is an example of this, for he steadily deteriorated through his efforts to do more than he was able. The same remark applies in our own day to Jacopo da Pontormo, and may be seen in many others, as I have related and shall relate again. Perhaps this is because when Heaven has distributed favours it wishes men to rest content with their share.

Having spoken upon these questions of art, possibly at greater length than was necessary, I will now return to Raphael.

A great friend of his, Bernardo Dovizi, cardinal of Bibbiena, had for many years urged him to take

Opposite: Study for Christ in Glory, 1519-20

a wife. Raphael had not definitely refused, but had temporised, saying he would wait for three or four years. At the end of this time, when he did not expect it, the cardinal reminded him of his promise. Feeling obliged to keep his word, Raphael accepted a niece of the cardinal for wife. But being very ill-content with this arrangement, he kept putting things off, so that many months passed without the marriage taking place. This was not done without a purpose because he had served the court so many years, and Leo was his debtor for a good sum, so that he had received an intimation that, on completing the room which he was doing, the Pope would give him the red hat for his labours and ability, as it was proposed to create a good number of cardinals, some of less merit than Raphael.

Meanwhile Raphael continued his secret pleasures beyond all measure. After an unusually wild debauch he returned home with a severe fever, and the doctors believed him to have caught a chill. As he did not confess the cause of his disorder, the doctors imprudently let blood, thus enfeebling him when he needed restoratives. Accordingly he made his will, first sending his mistress out of the house, like a Christian, leaving

Opposite: Female Figure with a Tibia, and Ornamental Studies, 1504-08

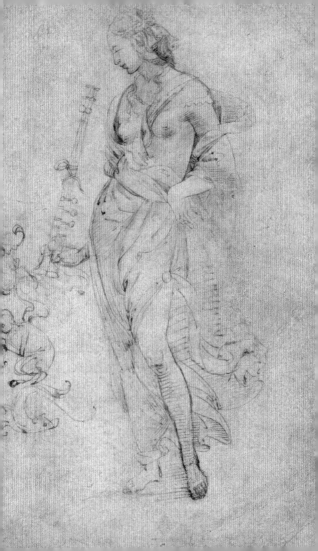

her the means to live honestly.[1] He then divided his things among his pupils, Giulio Romano, of whom he was always very fond, Cio. Francesco of Florence, called 'il Fattore' and some priest of Urbino, a relation. He ordained and left a provision that one of the antique tabernacles in S. Maria Rotonda should be restored with new stones, and an altar erected with a marble statue of the Madonna. This was chosen for his tomb after his death. He left all his possessions to Giulio and Cio. Francesco, making M. Baldassare da Pescia, then the Pope's datary, his executor. Having confessed and shown penitence, he finished the course of his life on the day of his birth, Good Friday, aged thirty-seven. We may believe that his soul adorns heaven as his talent has embellished the earth. At the head of the dead man, in the room where he worked, they put the Transfiguration, which he had done for the Cardinal de' Medici. The sight of the dead and of this living work filled all who saw them with poignant sorrow. The picture was placed by the cardinal in S. Pietro in Montorio, at the high altar, and was always prized for its execution. The body received honoured burial, as befitted so noble a spirit, for there was not an artist who did not grieve or who

(1) Maria Bibbiena; but she seems to have died before the artist.

failed to accompany it to the tomb. His death caused great grief to the papal court, as he held office there as groom of the chamber, and afterwards the Pope became so fond of him that his death made him weep bitterly. O happy spirit, for all are proud to speak of thee and celebrate thy deeds, admiring every design! With the death of this admirable artist painting might well have died also, for when he closed his eyes she was left all but blind. We who remain can imitate the good and perfect examples left by him, and keep his memory green for his genius and the debt which we owe to him. It is, indeed, due to him that the arts, colouring and invention have all been brought to such perfection that further progress can hardly be expected, and it is unlikely that anyone will ever surpass him. Besides these services rendered to art, as a friend he was courteous alike to the upper, the middle and the lower classes. One of his numerous qualities fills me with amazement: that Heaven endowed him with the power of showing a disposition quite contrary to that of most painters. For the artists who worked with Raphael, not only the poor ones, but those who aspired to be great – and there are many such in our profession – lived united and in harmony, all their evil humours disappearing when they saw him, and every vile and base thought deserting their mind. Such a

thing was never seen at any other time, and it arose because they were conquered by his courtesy and tact, and still more by his good nature, so full of gentleness and love that even animals loved him, not to speak of men. It is said that he would leave his own work to oblige any painter who had known him, and even those who did not. He always kept a great number employed, assisting and teaching them with as much affection as if they had been his own sons. He never went to court without having fifty painters at his heels, all good and skilful, who accompanied him to do him honour. In short, he did not live like a painter, but as a prince. For this cause, O Art of Painting, thou mayest consider thyself fortunate in having possessed an artist who, by his genius and character, has raised thee above the heavens. Blessed indeed art thou to have seen thy disciples brought together by the instruction of such a man, uniting the arts and virtues, which in Raphael compelled the greatness of Julius II and the generosity of Leo, men occupying the highest dignity, to treat him with familiarity, and practise every kind of liberality, so that by means of their favour, and the wealth they gave him, he was able to do great honour to himself and to his art. Happy also were those who served under him, because all who imitated him were on a safe road, and so those who imitate his labours in

art will be rewarded by the world, as those who copy his virtuous life will be rewarded in heaven. Bembo wrote the following epitaph for Raphael:

D. O. M

RAPHAELI SANCTIO IOAN. F. URBINAT.

PICTORI EMINENTISS. VETERUMQ. ÆMULO,

CUIUS SPIRANTEIS PROPE IMAGINEIS

SI CONTEMPLERE

NATURÆ ATQUE ARTIS FŒDUS

FACILE INSPEXERIS.

IULII II ET LEONIS X PONTT. MAXX.

PICTURÆ ET ARCHITECT. OPERIBUS

GLORIAM AUXIT.

VIXIT AN. XXXVII INTEGER INTEGROS

QUO DIE NATUS EST EO ESSE DESIIT

VIII ID APRIL MDXX

ILLE HIC EST RAPHAEL TIMUIT QUO SOSPITE VINCI

RERUM MAGNA PARENS QUO MORIENTE MORI.[1]

(1) To the Glory of God. In memory of Raphael, son of Giovanni Santi of Urbino; greatest painter and rival of the ancients, whose almost-breathing likenesses if you contemplate, you straightway will see Nature and Art conjoined; who by his works in painting and in architecture did increase the glory of the Pontiffs Julius II and Leo X; who lived in goodness thirty-seven good years, and died on his birthday, 6 April 1520.

Here lies that famous Raphael by whom Nature feared to be conquered while he lived, and when he was dying, feared herself to die.

GIORGIO VASARI

The Count Baldassare Castiglione wrote of his death as follows:

Quod lacerum corpus medica sanaverit arte,
Hippolytum Stygiis et revocarit aquis;
Ad Stygias ipse est raptus Epidaurius undas;
Sic precium vitæ mors fuit artifici.
Tu quoque dum toto laniatum corpore Romam
Componis miro, Raphael, ingenio;
Atque Urbis lacerum ferro, igni, annisque cadaver
Ad vitam, antiquum jam revocasque decus.
Movisti superum invidiam, indignataque mors est,
Te dudum extinctis reddere posse animam.
Et quod longa dies paullatim aboleverat, hoc te
Mortali spreta lege parare iterum.
Sic, miser, heu! prima cadis intercepte juventa;
Deberi et morti, nostraque, nosque mones.[1]

(1) Because he healed with his art the broken body, and called back Hippolytus from the shores of death, Æsculapius himself was dragged to the Styx, and died for being master of life. Thus with you, Raphael, who healed the body of our City, wounded with sword and fire and years, and brought Rome back to the life and glory of its ancient times: you roused jealousy in the Gods, and Death itself is indignant that you were able to give life back to what was dead, and defy his law, renewing what had been lost over many years; and so, alas, unfortunate Raphael, you were taken in the very flower of youth, and warn us now that all we have, we owe to death.

List of Illustrations

Photographs on pp. 9, 13, 33, 43, 46-47, 50-51, 56-57, 58, 66-67, 70-71, 77, 83, 86,
90-91 and 98 courtesy Wikimedia Commons; on pp. 36, 88, 96 and 104-105
courtesy Google Art Project; on pp. 116 and 119 courtesy The J. Paul Getty
Museum; on pp. 4, 6, 28 and 78 courtesy National Gallery of Art, Washington
DC; on pp. 39 and 84 courtesy The Metropolitan Museum of Art; on pp. 20 and
100-101 © Miguel Hermoso Cuesta; on pp. 18-19 courtesy Victoria and Albert
Museum/V&A Images; on pp. 1, 2, 23, 62, 74, 81 and 106 © Bridgeman Art
Library; on p. 14 © British Museum; on p. 108 courtesy Rijksmuseum

Published in the United States of America in 2018 by the J. Paul Getty Museum, Los Angeles
Getty Publications
1200 Getty Center Drive, Suite 500
Los Angeles, California 90049-1682
www.getty.edu/publications

Distributed in the United States and Canada by the University of Chicago Press

Printed in China

ISBN 978-1-60606-563-1
Library of Congress Control Number: 2017946356

Published in the United Kingdom by Pallas Athene
Studio 11A, Archway Studios, 25–27 Bickerton Road, London N19 5JT
Series editor: Alexander Fyjis-Walker Editorial assistant: Anaïs Métais

Vasari text first published 1550, revised edition 1568; translation by A. B. Hinds;
epitaphs translations by Pallas Athene

Front cover: Raphael (Italian, 1483–1520), *Self-Portrait*, 1506 (detail). Uffizi, Florence, Italy.
Photo: Erich Lessing / Art Resource, NY